SPECIAL EFFECTS
PHOTOGRAPHY

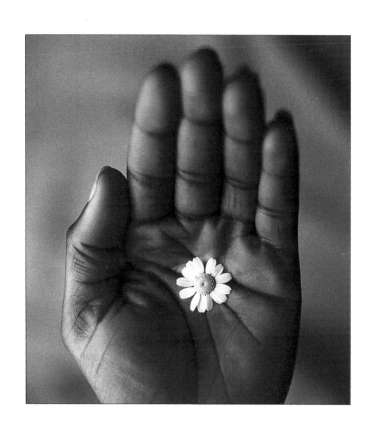

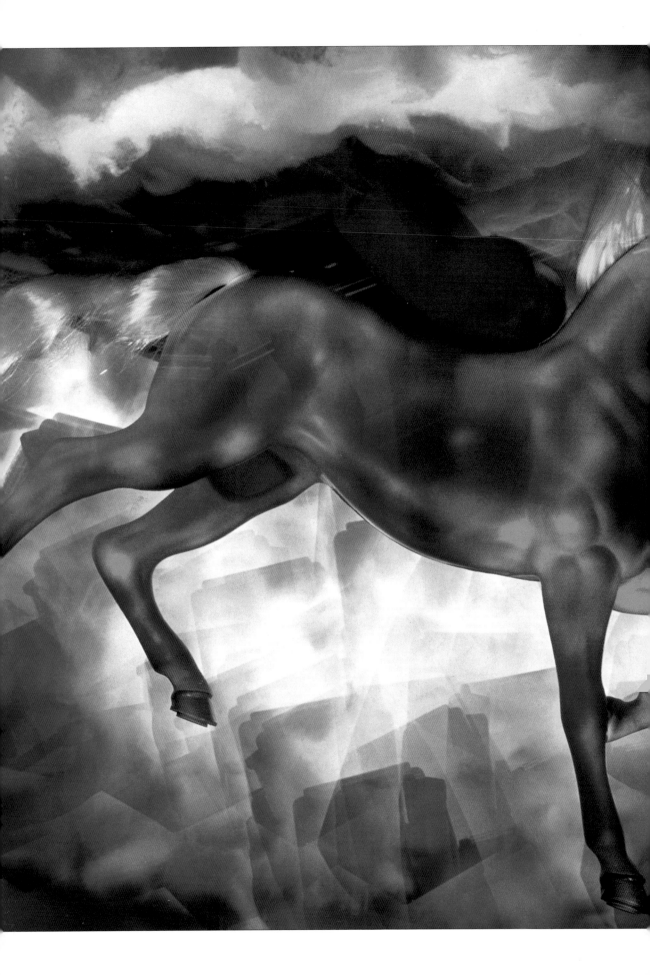

ROTOVISION
PRO-PHOTO SERIES

SPECIAL EFFECTS PHOTOGRAPHY

DAVID DAYE

A RotoVision Book

Published and distributed by RotoVision SA
Rue Du Bugnon 7
1299 Crans-Pres-Celigny
Switzerland

RotoVision SA, Sales & Production Office
Sheridan House, 112/116A Western Road
HOVE BN3 1DD
Tel: +44-1273-7272-68
Fax: +44-1273-7272-69

Distributed to the trade in the United States:
Watson-Guptill Publications
1515 Broadway
New York, NY 10036

ISBN 2-88046-268-1

Author David Daye
Design by Phil Kay
Illustrations by Kate Simunek
Picture research by David Daye

Printed in Singapore by Teck Wah Paper Products Ltd
Production and separation in Singapore by ProVision Pte Ltd
Tel: +65-334-7720
Fax: +65-334-7721

Photographic credits
Front cover: Patrick Barta
Page 1: Alan Powdrill
Pages 2–3: Andreas Baier
Back cover: Andrew Cameron

CONTENTS

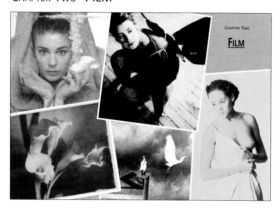

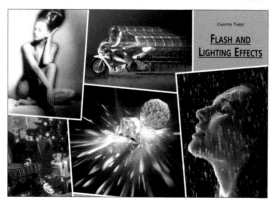

Contents

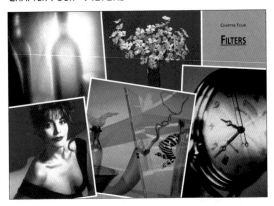
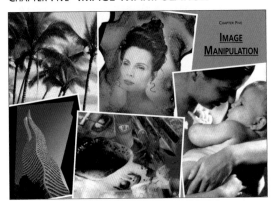

INTRODUCTION

Professional photographers, and their clients, are constantly looking for new and exciting images, or ways to create them. This book shows just some of the results that are possible by using photographic special effects.

A special effect can be something as simple as a two-stop alteration in the exposure or as complex as an electronically manipulated photograph. What is important is that the image should have visual impact. If the resulting image pleases the photographer and arouses the client's interest and also fulfills a client's needs then the special effect has done its job.

Among the following pages there are new special effects techniques as well as new ways to produce traditional ones. There are very simple ones and there are complicated ones.

At the very least, many of the images shown here will encourage photographers – first-time pros as well as more established ones – to do some experimentation of their own and add to their portfolios.

There are as yet other special effects techniques that are waiting to be discovered by the curious and the creative photographer. A book like this will help them in their search.

Included with each special effect image is clear information on how the shot was achieved, including technical details plus suggested tips, as well as simple diagrams.

This information will be especially useful to those taking their first steps into professional photography.

The images here have been chosen with care from some of the best work of international professional photographers. It comprises a gallery of visual ideas that will feed the imaginations of photographers, designers and picture buyers, in fact, all those who appreciate beautiful, inventive images.

Special Effects

Special effects have been an important part of photographic technique since the very beginning. In fact the earliest photographic lenses had certain characteristics such as overall softness and darkening at the corners that today's filter makers include in their ranges. These

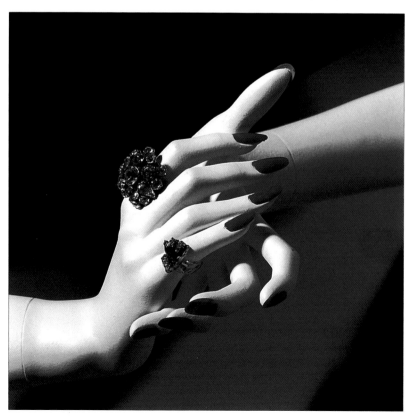

PHOTOGRAPHER:
Fina Lunes

CAMERA:
**Hasselblad
with 150mm lens**

FILM:
Kodak T-Max 100

EXPOSURE:
1/125 second at f8

LIGHTING:
One studio flash

PURPOSE:
**Ediciones Musicales
Horus, S.A.**

◀ *Toning is based on a black and white original but produces a result that is neither black and white nor a conventional color image. Different toning colors include: sepia, yellow, purple and even gold.*

take the form of soft focus filters and vignetting masks.

A good special effect can make a great shot look even better, or different, and certainly eye-catching. And if a client is presented with a straight shot alongside a special effects version of it, more often than not (and everything else being equal) the client will go for the special effects shot. So the professional photographer, by using the appropriate effect, has a considerable amount of power to control the degree of impact that he or she can add to an image.

Tools for special effects

The following information, by no means comprehensive, is a guide to first-time pros equipping their studios for special effects work.

IN-CAMERA: Simple adjustments of the shutter speed and aperture can produce a range of basic special effects.

Also, the advanced features in today's sophisticated 35mm SLRs are perfect for special effects work. The following is a list of some of the features on offer, along with suggested effects they could be used for.

Multiple exposure – Most mid to high level SLRs offer this feature electronically. Some allow the user to dial in the number of multiple exposures required.

Automatic exposure bracketing – This is a much smoother and quicker alternative to manual bracketing. The photographer can choose up to + or - 3 or even 5 frames of adjusted exposure.

Spot-metering – Enables spot-readings, to create some dramatic effects.

FILM: Black and white infrared film is renowned for the glow effect it gives to sunlit scenes, especially those that include trees and grass. A little known feature of this film is that skin blemishes on portrait subjects become less noticeable.

Color infrared film produces unreal colors and is ideal for photographers who want to achieve a bizarre, off-beat result. Further variations in colors can be produced with specialized filters.

Kodak produces black and white and color infrared film, while Konica's and Ilford's IR films are black and white. These films need careful handling as they are sensitive to infrared light waves that are not visible to the naked eye. So they need to be used in controlled conditions.

However, as Konica's and Ilford's films are sensitive to a slightly narrower

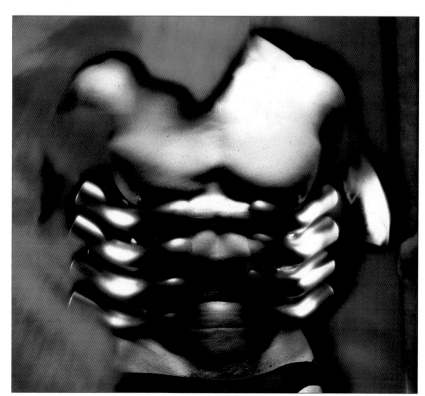

PHOTOGRAPHER:
Spencer Rowell

CAMERA:
**Hasselblad
with 120mm lens**

FILM:
Fuji 64T, and line film

EXPOSURE:
Not known

LIGHTING:
**Elinchrom flash
and tungsten Redheads**

PURPOSE/CLIENT:
For Bio Plus

◀ *This was created by double-exposing an image of a male torso with that of a set of exhaust pipes, specially built by a model-maker. The image conveys an impression of strength and stamina.*

◀ *Image transfer produces results quite unlike any other photographic process. The type of paper used is a vital element.*

PHOTOGRAPHER:
Charlie Lim

CAMERA:
**Sinar P 5x4
with 240mm lens**

FILM:
Polacolor 100

EXPOSURE:
B setting at f22

LIGHTING:
Light-painting device

PURPOSE:
For client's calendar

band of infrared wavelengths than Kodak's film, they have handling and usage similar to conventional film.

Kodak b&w infrared film is ideal for grainy results, and its wide sensitivity range can lead to dramatic results. It is also available in sheet film sizes.

Infrared film emulsions, as well as Polaroid's instant 35mm film range, are easily scratched and need to be carefully-handled and used.

FILTERS: A filter (also called a gel) is probably the most popular and accessible special effects accessory. Filters are available as round screw-on types or shaped to be slotted in to special holders.

Most filter manufacturers have a wide range of filter types for color and black and white film. Standard filters include those that reduce UV light, polarizers and color correction filters.

Most manufacturers also sell a range of soft focus, diffusion and color graduat-ed filters. Others also have polarizers in different colors, plus more specialized types eg. rainbow filters.

Larger filters in the form of sheets that can be used to cover studio lights are also available.

FLASH: A standard studio flash provides a good basis for special effects work. A good range of power ratios allows the lighting to be fine-tuned if necessary. Also worth having is a large selection of studio flash attachments such as barn doors, snoots, honeycomb diffuses, spot-lights, umbrellas and softboxes.

The light brush is a flexible lighting tool, useful for normal, as well as special effects photography.

Many high-level 35mm SLRs have advanced flash facilities that can be used for effects. Second-curtain flash synchro-nization (see Glossary), strobe-type flash and slow sync flash are ideal features for the photographer wishing to experiment.

IMAGE MANIPULATION: Most of the dark-room techniques used for the images in this book are not difficult to master. And some of the simpler ones, such as toning, require just a basic knowledge of dark-room procedure. A skilled darkroom worker, however, will be capable of pro-ducing exceptional special effects work.

Total familiarity with various process-ing and printing techniques plus constant practice will form a good foundation for producing high quality special effects in the darkroom.

Electronic imaging is able to solve many creative problems and has intro-duced time- and labor-saving short-cuts for the busy professional photographer.

It also provides a new range of creative options that can free the imagi-nation of the photographer who wants to create unusual and eye-catching images. With its features, its flexibility, plus an extensive range of controls, it is an ideal tool for special effects.

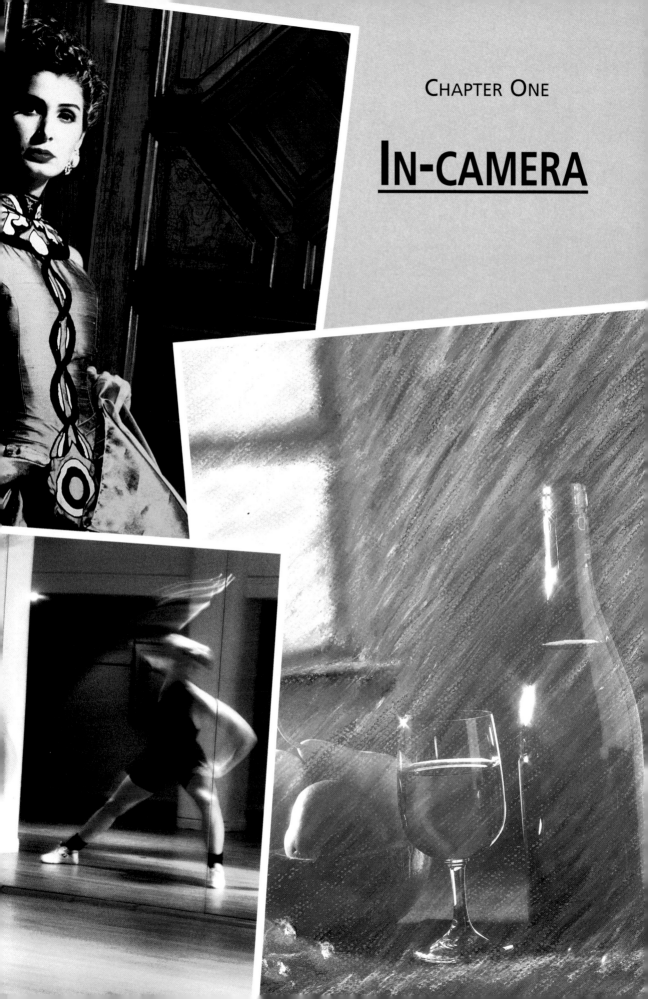

CHAPTER ONE

IN-CAMERA

SIMPLE DOUBLE EXPOSURE

Double exposure means taking two photographs on one frame of film. To be able to do this, an adjustment is made to the camera so that the wind-on lever is temporarily disengaged after taking the first shot (see TIPS). This makes the film stay on the same frame. The photographer can then take a second shot on this frame, creating the double exposure.

NB. If you use a straight exposure reading for both images, the same area of film will receive twice the amount of light, and the result will be overexposure. The second image therefore needs less light so that the final double-exposed image shows correct and even exposure. This is vital when using slide film.

To do this the exposure reading has to be divided into half. To create a correctly exposed double exposure a setting of, say, $\frac{1}{125}$ sec at f8 would therefore require a shutter speed of $\frac{1}{60}$ sec for each of the two images.

(An alternative way is to change the aperture accordingly, though this will affect the depth of field.)

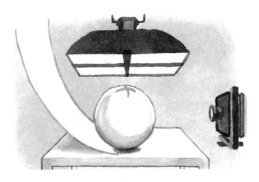

▶ This double-exposure was done in-camera, using the traditional technique of taking two photographs on the same frame of film.

PHOTOGRAPHER:
Rick Muller

CAMERA:
5x4 with 210mm and 300mm lenses

FILM:
Kodak Ektachrome 100

EXPOSURE:
1st exposure: f45
2nd exposure: f32

LIGHTING:
Light bank with honeycomb diffuser. Elinchrom 404 flash-head at full power

PURPOSE:
Perrier

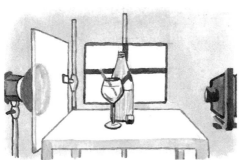

▲ The double exposure was created in two stages. The first shot (top) was of the sphere. A special cross-shaped mask was used over the softbox to create the 'window' reflection on the glass sphere.

For the second shot (above) the lighting was then re-positioned behind, and to the side of, the bottle and glass. The lighting set-up was carefully chosen to emphasize the transparent nature of all the glass objects.

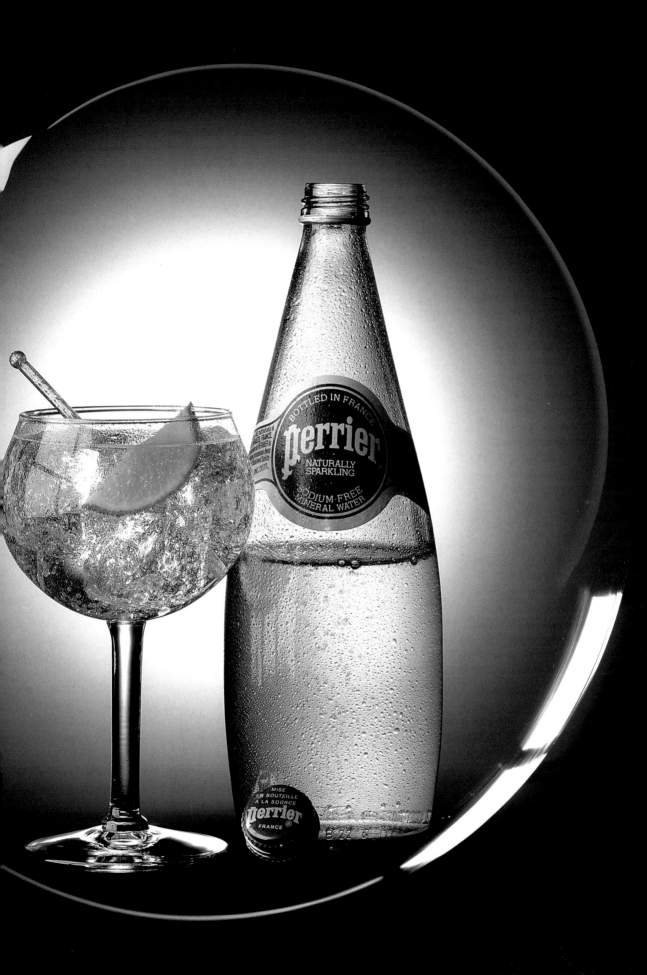

ADVANCED MULTIPLE EXPOSURE

Multiple exposure involves combining one or more photographs into a single image. Combining a photograph with a drawing to produce a single image is a different way to achieve a multiple exposure. As expected, it requires drawing as well as photographic skills. Here's how this advanced multiple exposure was created:

A simple still life was set up in front of a black background. Then a piece of acetate was taped to the ground-glass (viewing) screen of the 5x4 camera. Using a marker pen the photographer drew an outline of the still life shapes onto the acetate. This outline was placed on a photocopying machine and enlarged. The enlarged outline was then traced onto a large sheet of Canson paper. This is a special type of paper that is used by artists for pastel drawing.

Pastel streaks were drawn across the sheet of paper, and a window was drawn in at the top left corner.

Double-exposures were created by photographing the still life subject and photographing the pastel drawing, both on the same frame of film.

Several double-exposures were needed until the required effect was achieved: an image that is half-photograph and half-illustration.

PHOTOGRAPHER:
Stuart Simons

CAMERA:
Two cameras – Arca Swiss and Sinar

FILM:
Kodak Ektachrome 100 Plus

EXPOSURE:
Not known

LIGHTING:
Speedotron studio flash with diffusion plus two spotlights

PURPOSE/CLIENT:
For a pharmaceutical client

▶ *This image might seem to be an example of electronic image manipulation. It is actually a double exposure.*

▲ *A photograph was first taken of the pastel streaks that were on the drawing paper. The paper was then photographed.*

▲ *The still life set-up was then photographed on the same frame of film, so that the pastel and still life became one.*

Hints and tips

● Two cameras were used for this image. The double exposures were made simply by transferring the same sheet of film, in the film holder, into the second camera and re-photographing.

● The illustration can be made to seem almost transparent, depending on the length of the exposure.

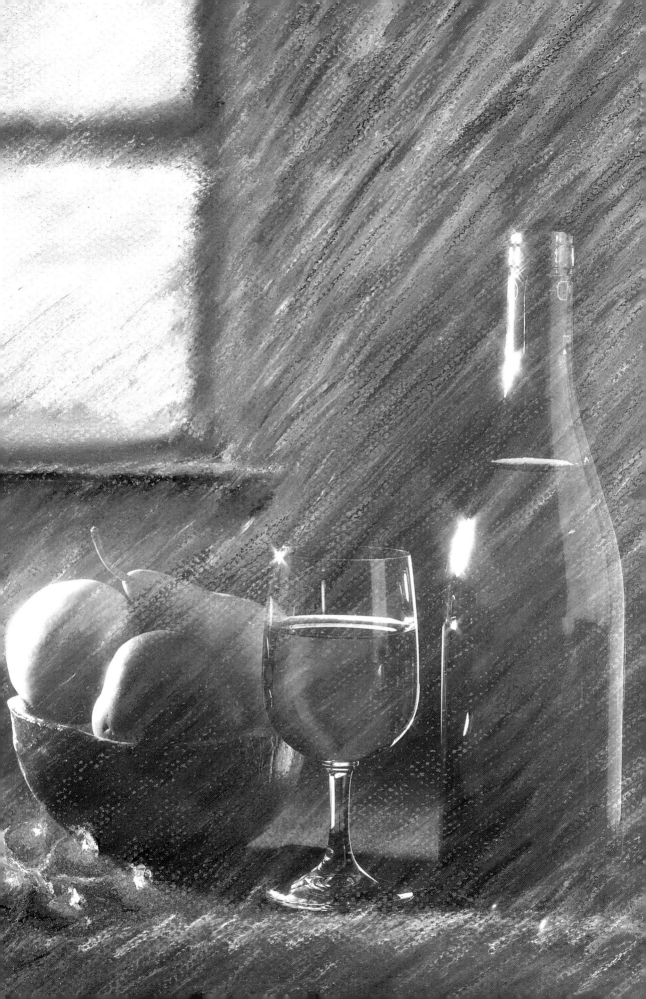

HIGH CONTRAST

High contrast is normally avoided in general photography, yet it can sometimes be of benefit to the photographer. In fact, if it's used with the right subject and in a studio situation, high contrast itself can be used as a special effect.

Photographer Ben Lagunas knew that he had to show the rich colors and texture of the silk dress. He felt that using even lighting would not produce the result he wanted, so he decided instead to use a high contrast lighting set-up to fully emphasize the features of the dress.

How it was done:

The studio flash units were set on full power and lit the woman's face and the dress. Just a single diffusion panel was used for the lighting on this side. The strong lighting also created some dark shadow areas behind the pillar and the model.

Black panels were then placed at the model's right-hand side to increase the shadows there.

The finishing touch was the use of transparency film. This has higher contrast than color negative film and so added another degree of contrast.

PHOTOGRAPHER:
Ben Lagunas

CAMERA:
Hasselblad with 80mm lens

FILM:
Kodak Ektachrome 100 Plus rated at ISO 80

EXPOSURE:
⅟₆₀ second at f16

LIGHTING:
Two Broncolor Prime Fashion Strobes

PURPOSE:
Diva Collection

▶ *High contrast can be used for dramatic effect. Here it has emphasized the brightness and rich detail in the material of the woman's dress.*

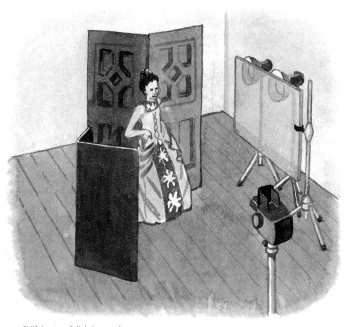

▲ *Skilful use of lighting and props has given the impression that this was photographed on location. The heavy door which was carefully positioned provided the perfect background for the woman and the dress.*

Hints and tips

● Make sure that the subject you're photographing has strong colors. Pale colors may look 'washed-out' in high contrast situations.

● Bright sunshine is perfect for high contrast photography outside the studio. Of course, the exposure setting will then need to be increased slightly to avoid under-exposure in high contrast scenes, especially when photographing bright or reflective areas.

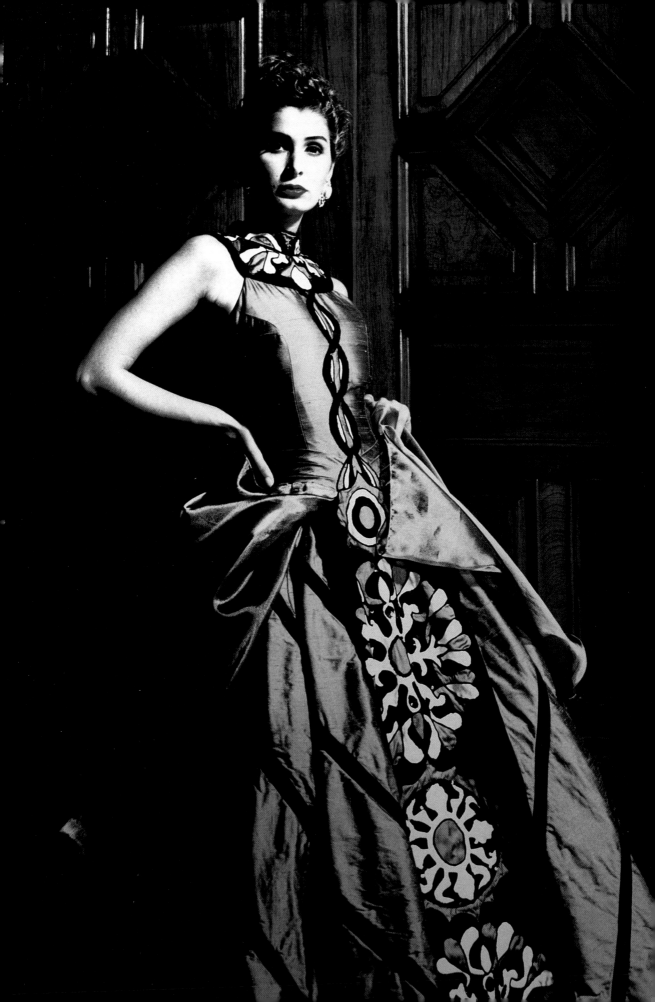

SHARP — AND BLURRED

A very slow shutter speed plus a fast-moving subject will produce streaks of color that give an impression of movement. Sometimes the effect can be so strong that the shape of the subject is unclear. A way to show sharpness and blur in an image is to use a slow shutter speed plus flash.

Here the photographer has used tungsten lights as the main source of illumination. The flashgun used was a small one that could provide a low power output. The result is that the flash has illuminated and frozen parts of the girl as she moved, while the slow shutter speed has captured the rest of her movement as a blur.

PHOTOGRAPHER:
Daniel Allan

CAMERA:
Nikon F4 with 105mm lens

FILM:
**Fujichrome 100
cross-processed in C41**

EXPOSURE:
⅓s second at f8

LIGHTING:
**Two tungsten lights plus
low-powered flash**

PURPOSE/CLIENT::
Portfolio

▲ The photographer took a series of shots from one position. The tungsten lights provided the main lighting, while the flash illuminated parts of the moving subjects.

▲ The photographer knew that tungsten lighting produces a warm color cast with daylight film, and decided to retain it. The selected shutter speed gave just the right amount of blur.

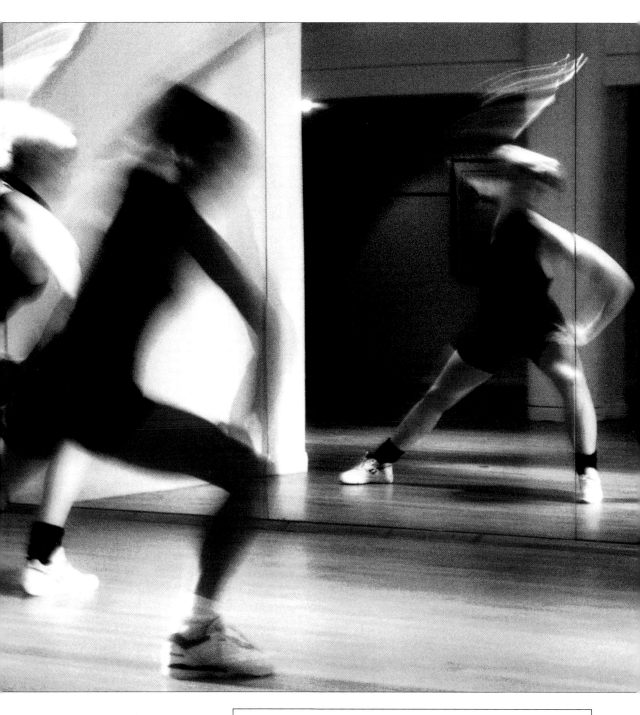

Hints and tips

● It can be difficult getting a good composition when photographing moving subjects. A telephoto lens can provide a tighter composition.

● The warm coloring provided by tungsten lighting – noticeable even after cross-processing – can look acceptable for some kinds of interior portraiture.

SLOW SHUTTER SPEED

It is important to choose the right shutter speed that will successfully capture a subject, whether it's moving or still. And if you're photographing something where the light itself is the main part of the scene, such as a fireworks display, then it's vital to choose the right slow shutter speed that will record the subject on film.

A very low slow shutter speed would, in this shot of an industrial laser at work, turn the sparks into long streams of light. On the other hand a much higher slow shutter speed would only show a few sparks.

The shutter speed that was chosen, after several Polaroid tests, was ¼ sec.

This successfully captured a sequence of sparks as the laser came into contact with the metal.

Keep it steady

The first problem to cope with when using slow shutter speeds is camera shake, especially when photographing outdoors. Shutter speeds of around ⅟₆₀ second and slower greatly increase the risk of camera shake. If you have to use these speeds then it is wise to use a special shoulder support, a mini tripod or, at the very least, a nearby tree or wall. But there is no substitute for a solid tripod, which can provide steadiness plus some camera adjustability.

PHOTOGRAPHER:
Gösta Wendelius
CAMERA:
Hasselblad with 150mm lens plus extension rings
FILM:
Kodak Ektachrome Plus 100
EXPOSURE:
¼ second at f16
LIGHTING:
Two Pro 3 flash units
PURPOSE:
To illustrate Duroc laser surface impregnation

▶ *A fraction of a second is a very long time when photographing a rapidly moving subject. The trails of sparks in this industrial shot were the result of a ¼ second exposure.*

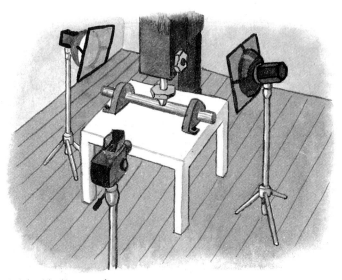

▲ *Industrial subjects are often difficult to turn into creatively successful images. Here the photographer's use of red and blue filters produces an attractive result yet doesn't obscure the main area of interest.*

Hints and tips

● A slow to medium speed film is better for slow shutter speeds as it will give:
 a) easier access to slow shutter speeds than a fast film
 b) better image quality.

● Experiment with different shutter speeds if you're photographing a subject with sparks like the above.

● If you're photographing fireworks the simplest method is, firstly, to choose a small aperture such as f11, f16 or f32. Then set the camera to B and leave the shutter open for the duration of a fireworks sequence.

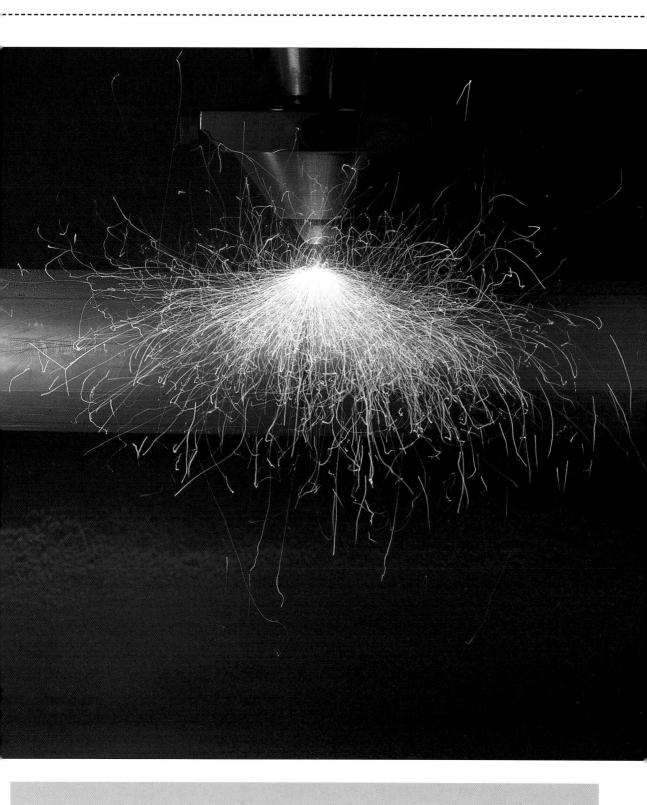

REFLECTIONS

Reflections, especially of subjects at close distances, are difficult to control in photography. There's always a risk that the photographer or his camera will be included in the reflection. And in a studio situation there's the likelihood that parts of the lighting or other equipment may accidentally be included in the frame.

The photographer of this image got around the problem by photographing a reflective subject from one side.

How it was done:
Water droplets were placed on a sheet of chrome steel. A reflection of this was seen on another piece of chrome steel that was bent and positioned nearby. Finally, the reflection of a corrugated acrylic board provided an interesting background pattern which looks like ripples.

PHOTOGRAPHER:
Kazuo Kawai

CAMERA:
Sinar 5x4 with 180mm lens

FILM:
Kodak Ektachrome 64 T

EXPOSURE:
3 sec at f22

LIGHTING:
500W tungsten floodlight below tracing paper, 300W tungsten floodlight behind acrylic board

PURPOSE:
Portfolio

▶ *The metallic reflections have given the impression that the spheres are solid, looking like ball-bearings. They are actually droplets of water.*

Hints and tips

● To avoid including a reflection of the camera, shoot the subject from an angle.

● A shot that includes a subject plus its reflected image in a highly reflective surface such as a mirror can, with careful positioning, make it seem like the subject is on water.

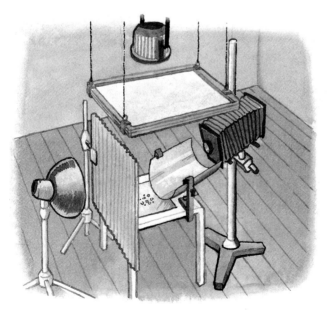

◀ *The bend of the reflective metal is an important part of the effect. When the best position is found a clamp will be needed to hold it in place.*

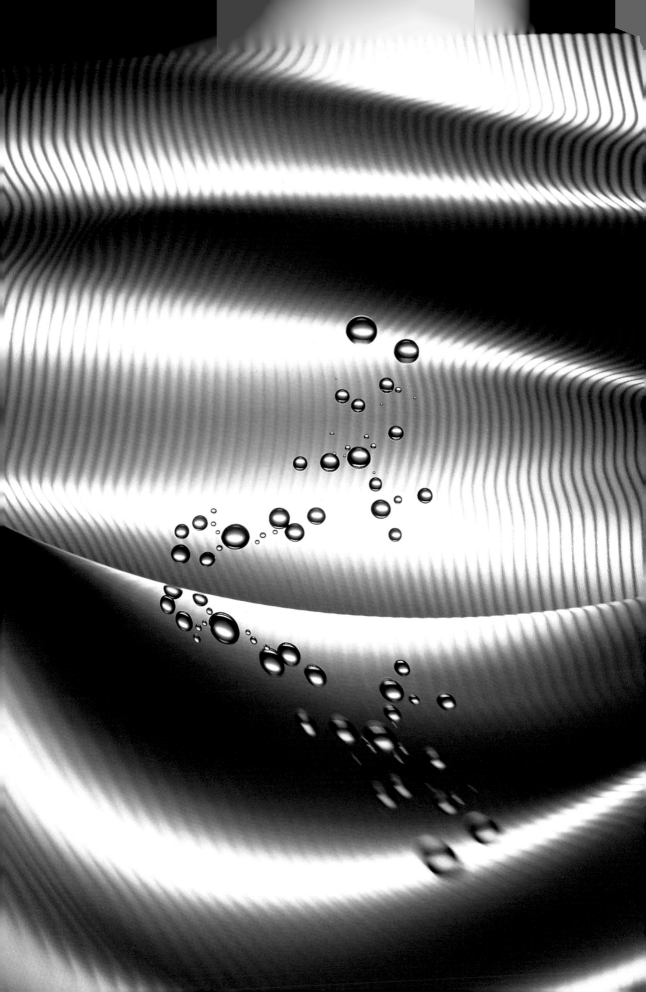

OVER-EXPOSURE FOR HIGH-KEY EFFECT---------------------------------

Over-exposure is a result that all the light-reading equipment and procedures used in photography try to avoid happening. At its worst it produces washed-out images that show little or no detail and that will reproduce poorly on a printed page. But selective over-exposure, that is, a carefully chosen exposure setting that will also show some detail can be used to create an interesting and useful result. Two or three stops is usually sufficient. The subject then takes on a lighter, misty appearance. Colors are also lightened and become like soft pastels.

It tends to be more successful with 'soft' subjects where detail is less important than an overall effect. Some suggested subject areas are: fashion photography, portraiture, still life, nature and landscape.

Mark Hilden photographed a series of models using a camera-mounted flashgun which was at full power. He increased the suggested reading by 2½ stops to create the over-exposed or high-key result. He used a fine grain slide film, though any film – fast and grainy or medium speed color, or black and white – can be used.

PHOTOGRAPHER:
Mark Hilden

CAMERA:
**35mm SLR
with 100–300mm zoom**

FILM:
Kodachrome 25

EXPOSURE:
**⅟₆₀ second at 2½ stops
over-exposed from
suggested aperture**

LIGHTING:
Xenon flash at full power

PURPOSE:
For Kobe Fashion Mart

▶ *Over-exposure increases the contrast, making light areas lighter, yet maintaining the dark areas. The overall result is a light and airy effect.*

▲ *The photographer used his zoom lens to isolate the model's face. He used a flash setting that he knew, from previous experience, would produce just the right amount of over-exposure.*

Hints and tips

● Bracketing shots by varying the exposure settings can provide a selection of options to choose from. These will also help in fine-tuning the strength of color to suit requirements.

● Shooting towards a light source produces flare spots or flare streaks, which can increase the high-key effect. Best examples will give the impression of light flooding through the image.

SHALLOW DEPTH OF FIELD

Depth of field in photography can be a useful special effects technique when used with some skill and imagination.

A lot of professional photography requires maximum depth of field to show all the details of a subject. But shallow depth of field has great potential in creating a special effects image with impact.

The photographer of this picture has created a narrow plane of sharp focus, while everything else in front of and behind this area is out of focus. The subject in the field of sharp focus stands out from the other items, attracting the viewer's attention.

Shallow depth of field was possible by using what would be considered a wide aperture in 5x4 photography. Also there were none of the special camera adjustments that, in large format photography, normally give extensive depth of field.

Finally the camera was tilted so as to give the image an off-beat look.

▲ The photographer knew the depth of field he would get using a particular lens and aperture set-up with his camera. So he positioned the objects on the table to get the required soft and sharp areas.

▶ Shallow depth of field can help to give an almost 3D effect to a sharply focused object, making it stand out from the de-focused surroundings.

PHOTOGRAPHER:
Charles Schiller

CAMERA:
5x4in with 240mm lens plus extension rings

FILM:
Fujichrome Velvia

EXPOSURE:
f11

LIGHTING:
Two Speedotron flashes in Softboxes and one Calumet Spot focusing spotlight

PURPOSE:
Portfolio

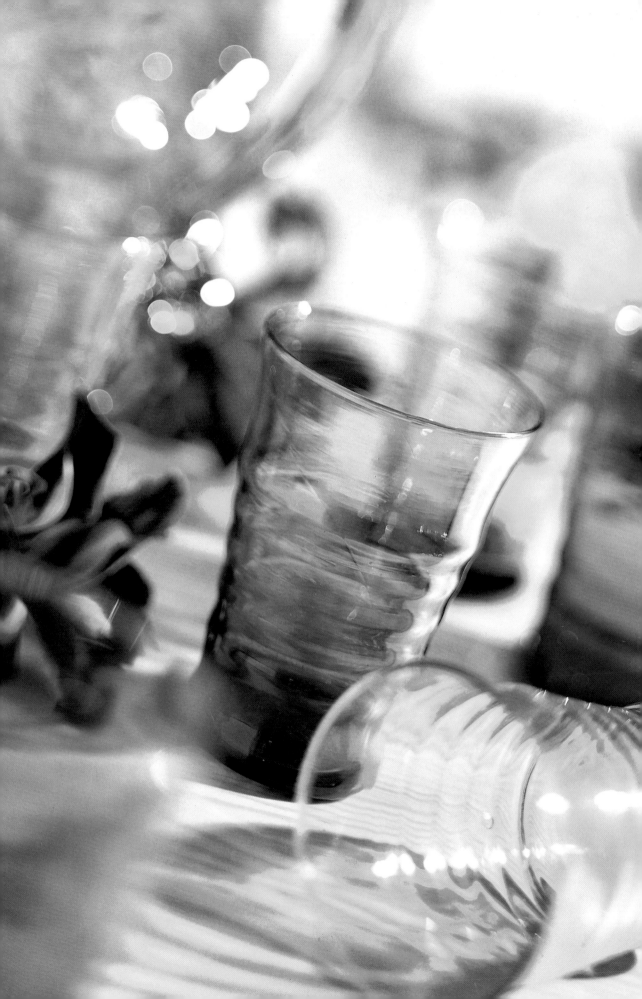

SLOW SHUTTER SPEED – WITH PANNING

The technique of panning – moving your camera in the same direction as a moving subject – is normally used to capture sharp images of fast-moving subjects. A slow shutter speed used with this technique can create a special effect that is full of impact.

A shutter speed of ⅕sec was used for these race-horses and their riders. When the photographer panned the camera he did it in one long, smooth and steady action.

The result is an image that is full of movement, yet it is still possible to see the horses and riders.

A shutter speed of ⅕sec is an excellent starting point for experimental images like this. It is slow enough to create blur yet just fast enough to show some image details.

▲ *The photographer and camera first of all need to be in a stable position. The panning is done in a steady, swinging action, moving in the same direction as the horses. The most common method is to press the shutter button at the beginning of the pan movement, and to release the shutter button just after it is completed. It's best to take several frames, to ensure a successful result.*

▶ *The slow shutter speed and pan movement has blurred the colors, producing an effect that is almost like a painting.*

PHOTOGRAPHER:
Greg Peas

CAMERA:
Nikon F4 with 300mm Nikkor lens

FILM:
Kodachrome 64

EXPOSURE:
⅕ second at f16

PURPOSE:
Stock image

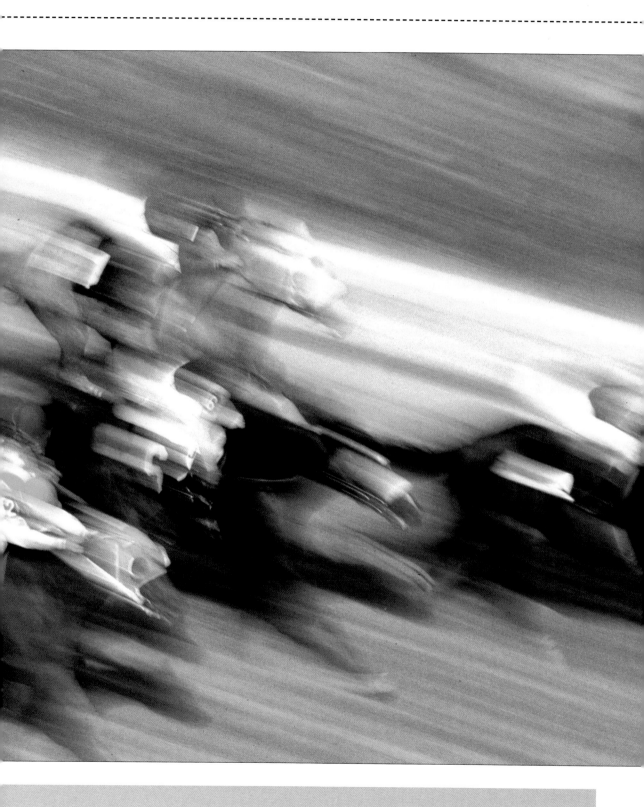

PANORAMIC FORMAT

Aphotographer who wants to show the full expanse of a landscape on film may find that even an ultra wide-angle lens will not be enough. A panoramic camera or a special film back that has an elongated panoramic frame will be able to capture a landscape subject in an all-encompassing way.

The difficult part is to compose your scene to make the most of such an eye-catching image-frame.

The landscape in the Western Highlands of Scotland is expansive and benefits from the scope of the 6x12 and 6x17 panoramic formats that the photographer used for the images on the opposite page and below.

Hints and tips

● A tripod will make it easier to keep the horizon line perfectly level for a panoramic shot. A hand-held panoramic format camera may be quicker to use but requires some skill in order to keep the horizons straight.

● An area of interest in the foreground is vital, as it will help to lead the viewer's eye into the composition.

PHOTOGRAPHER:
Tom Baker

CAMERA:
Linhof Technikardan with 360mm Nikkor plus 6x12 back, Linhof Technorama 6x17 with 90mm Super Angulon lens

FILM:
Kodak Panther 100

EXPOSURE:
1/30 second at f16 (6x12 image), 1/60 sec at f11 (6x17 image)

PURPOSE:
Portfolio

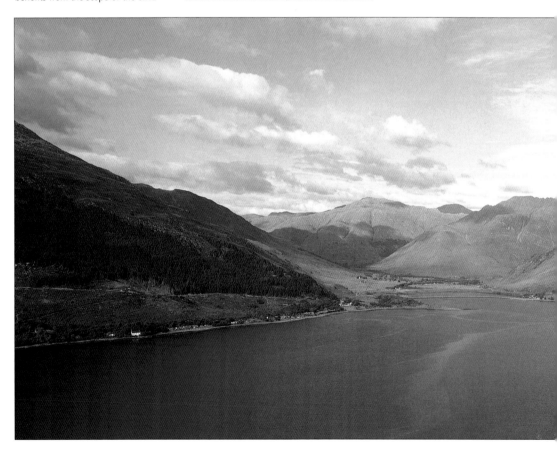

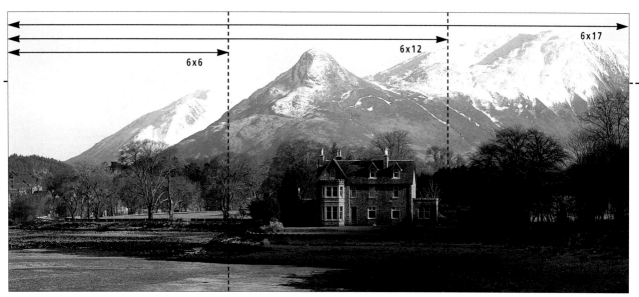

6x6　6x12　6x17

▲ It is important to be aware of what is going to be included when composing with the panoramic format, especially as dedicated panoramic cameras don't have through-the-lens viewing. A large format camera with a panoramic back allows more precise framing, as it has through-the-lens viewing.

▼ A panoramic image is immediately recognizable by its shape. Landscape is the most obvious subject-matter to use it for but the panoramic format also works well with group portraits in addition to some kinds of architectural photography.

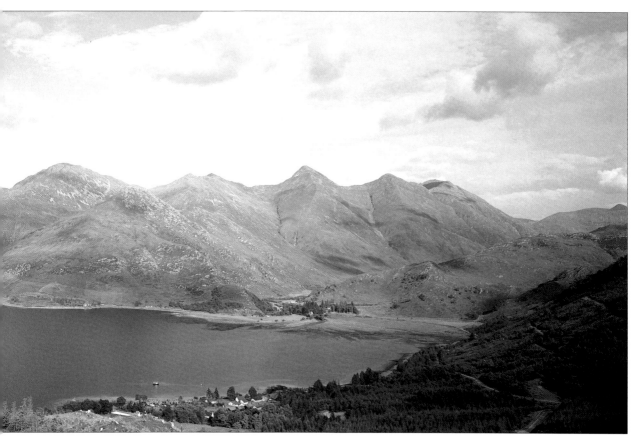

SILHOUETTE

Any object, when photographed against a strongly lit or bright background, will create a silhouette. The difficult part is in choosing an outline that can show, even as a silhouette, what the subject is in a clear and simple way.

When photographing outside it will be easy to find a bright background for a silhouette but not so easy to find the right silhouette subject to put in front of it. It's much easier to do this in a studio situation where all the elements can be easily adjusted, and instant film tests can be made.

Photographer Bienvenido Bautista controlled all the stages for the shooting of the silhouettes of two geishas and a Japanese screen.

Both main flashes were positioned behind the screen and aimed at the beige-colored background. A third (bounced) flash provided some illumination for the foreground.

The geishas were positioned so that their silhouettes would give a balanced composition.

The table provided a foreground area, and its polished surface reflected the silhouettes.

PHOTOGRAPHER:
Bien. S. Bautista

CAMERA:
**Hasselblad 500 CM
with 50mm Distagon lens
and 85B diffuser**

FILM:
Kodak Ektachrome 100 Plus

EXPOSURE:
1/30 second at f8

LIGHTING:
**Two Impact 41 flash heads
for the background, and
one Impact 41 flash for
foreground bounced flash**

PURPOSE:
Manila Hotel restaurant

▶ *Lighting or a bright highlight area behind any object will produce a silhouette. A good silhouette has shapes that are strong and simple.*

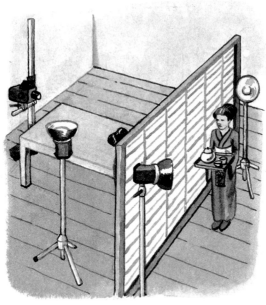

▲ *The two lights behind the screen were positioned so that they gave even illumination for the silhouetted background. The screen itself provided a series of squares that became silhouetted frames.*

Hints and tips

● Good silhouettes can be created from strong, simple shapes that have very few fine details.

● Try out different exposure settings. These will give a choice of different degrees of darkness for the silhouette.

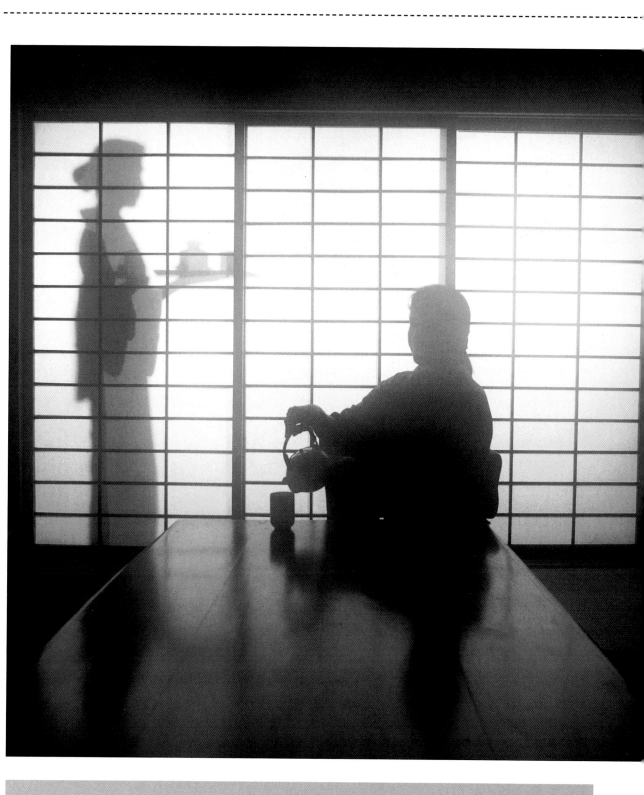

LOW-LIGHT PHOTOGRAPHY

Low-light photography is a whole new area of image creation for the special effects photographer. The most noticeable result of an image taken in low light will be a variation in the colors, called a color shift. For example, a blue evening sky may reproduce on the film as purple or even red.

These color shifts are caused by:

● the inability of normal (ie daylight) film to record colors accurately during exposures that last for seconds or even minutes.*

● the way that daylight film records artificial lighting, such as in street lamps or buildings.

Some color shifts are subtle, others more dramatic. This all depends on the film that is used, the length of the exposure, the existing natural and artificial lighting plus any filters that may be fitted. Remember, all filters reduce the light that enters the lens.

This low-light photograph of New York's Waldorf Astoria was taken from an adjacent building. The time was just after sunset.

This is called reciprocity law failure. There are filters and calculations that are available to provide near-accurate color correction in these conditions, for those photographers who require this information.

KEEP IT STEADY

1. If you don't have a full-size tripod with you, or a high ISO film which gives fast shutter speeds, an alternative is to use a shoulder pod or even a mini-tripod with a ball-socket head.

2. A monopod is yet another useful option. Its single leg can provide good steadiness when positioned against the photographer in a standing or kneeling stance.

3. In an emergency if you don't have any accessories for support you could use a nearby tree, lamp-post or wall. It's possible with a steady shooting position, plus a lot of luck (!), to use shutter speeds slower than $\frac{1}{30}$sec.

4. As a last resort, sitting on the ground with elbows braced on your knees will give a reasonably steady shooting position. Or try lying on the ground, again using your elbows as a support.

PHOTOGRAPHER:
Richard Berenholtz

CAMERA:
**Leica R4 SP
with 250mm lens**

FILM:
Kodak Ektachrome 100

EXPOSURE:
1 second at f8

LIGHTING:
Twilight

PURPOSE:
Portfolio

▶ *This was a straight shot taken on a 35mm SLR. The colors are the result of the film reacting with the longer than usual exposure time plus artificial lighting.*

Hints and tips

● Shutter speeds that last longer than around $\frac{1}{60}$ sec require a tripod and a cable release to give images that are free from blur.

● Bracket your shots, that is, take exposures at different shutter speeds (or apertures) not just the same one. You will then have a selection of shots from which you can choose the one that best suits your needs.

FISHEYE LENS

A fisheye lens comes with a ready-made special effect: straight lines are bent severely to create a strong bowed, almost circular, image. It's immediately recognizable and has instant impact not just for the bowed image but also for the fact that fisheye images are themselves barrel-shaped. With a true fisheye lens the image produced is a complete circle, while the rest of the frame is black.

Benefits: The extreme angle of view of a fisheye means that maximum image detail can be captured. A fisheye image is immediately recognizable by the extreme curving of straight lines.

The greater depth of field offered by a fisheye means that little or no focusing is required. It would certainly be difficult to differentiate between focused and unfocused areas in a scene.

Disadvantages: A fisheye lens, such as the 8mm optic used for the image shown here, is so ultra wide that it's possible to accidentally include your own feet or hands in the frame!

The extensive detail captured by a fisheye lens is barrel-shaped and such an image will therefore not give a true depiction of straight lines. So it's not recommended for subjects where a record of natural-looking dimensions is needed, for example, in architecture, nature or portraiture.

PHOTOGRAPHER:
Lanny Provo

CAMERA:
Nikon F4

LENS:
8mm f2.8 Fisheye

FILM:
Fujichrome Velvia

EXPOSURE:
$\frac{1}{125}$ second

TIME OF DAY::
4.30pm

PURPOSE:
For a Japanese agency

▲ Fisheye lenses are heavy because of the large front lens element. Most of them need attaching to a tripod. The design makes it difficult for frontal filter attachments so some have filter slots at the base, near the lens mount.

▶ Fisheye lenses produce images that are barrel-shaped or, as with this 8mm fisheye lens image, a complete circle. Careful composition was needed to make sure the horizon line was level.

Hints and tips

● To minimize fisheye distortion photograph subjects that have few or no straight lines.

● Horizontal lines will show little or no distortion if kept at the center of a fisheye image.

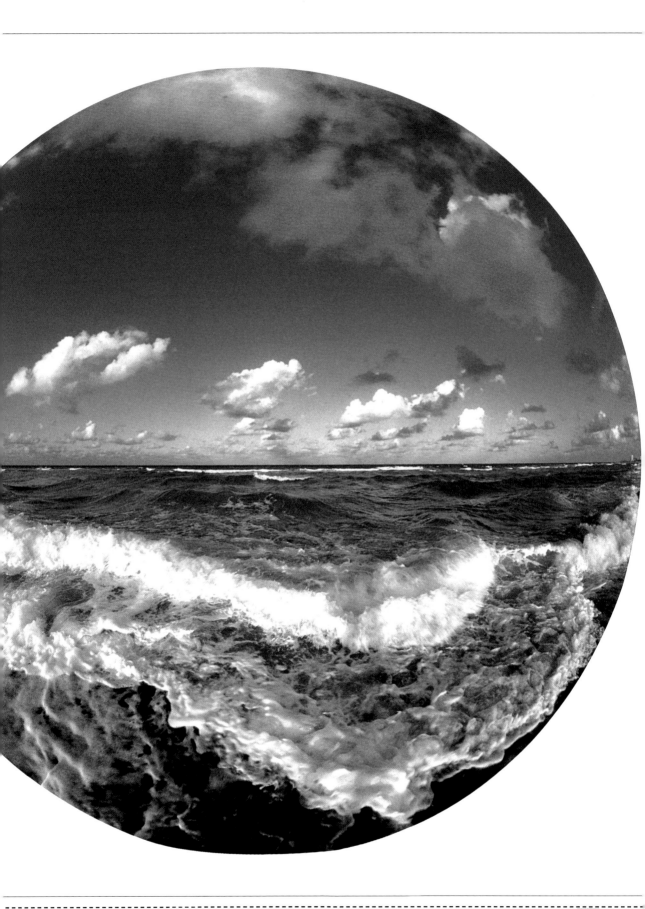

HIGH CONTRAST LINE PHOTOGRAPHY

Controllable light can be used to enhance a subject and make it look totally different.

In this image Joan Roig has created a super high contrast image that looks more like a drawing than a photograph. The photographer has created the dark and light areas by careful positioning of black and white reflectors. This has effectively removed the tones from the subject.

The high-contrast metallic shine of the bottle-opener plus the lighting and reflectors have combined to make this image succeed. The diagram below shows that a complicated set-up was required for this simple looking image.

▲ The reflectors help to create high contrast areas of dark and light while the special 'light tent' protects the shiny object from reflections. A light tent can be made from paper on a wood or plastic frame.

▶ All the tones have been removed from the object thanks to the carefully positioned lights and light-controlling accessories.

PHOTOGRAPHER:
Joan Roig

CAMERA:
**Sinar 5x4in
with 300mm lens**

FILM:
Kodak Ektachrome 100 Plus

EXPOSURE:
f32

LIGHTING:
**Two studio flash units
with honeycomb diffuser**

PURPOSE:
**MCA graphic design
company**

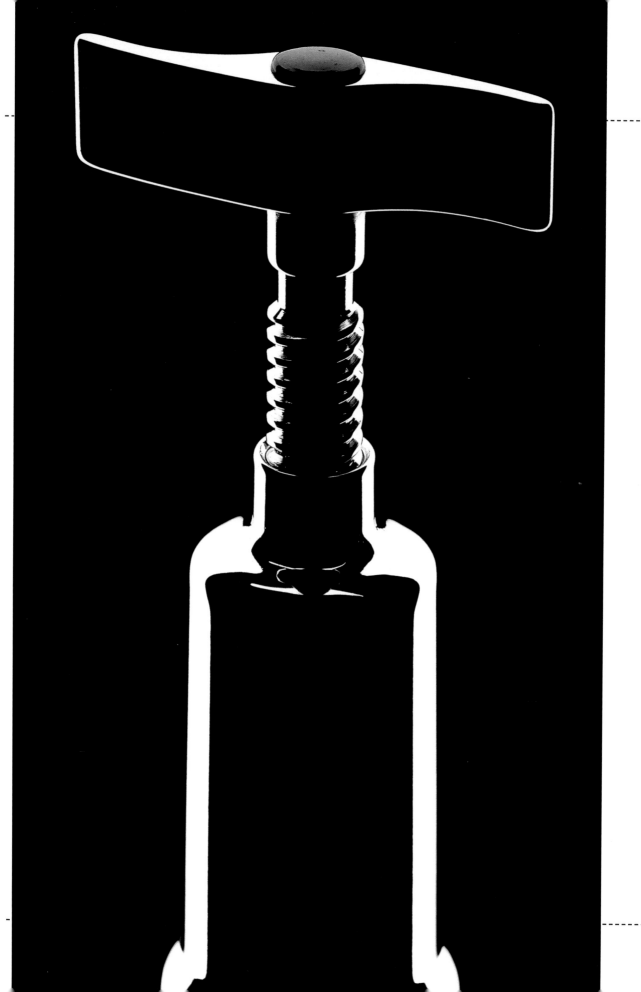

OVER-EXPOSURE PLUS HIGH CONTRAST PRINTING.....

Some of the best special effects are the simplest ones. Exposure adjustment, whether done by camera controls or in the darkroom, is a very simple procedure yet it can form the basis of many a great special effects photograph. Try small adjustments to begin with.

This was a straight shot, with the subject being lit directly by the sun. The exposure reading was taken from the eyes and no reflector was used to fill in the shadows.

The resulting high-key shot was then printed as a high contrast image. The halo effect is partly a result of this and partly a result of the original photographic exposure.

The right exposure

Built-in camera meters are calibrated to give a 'correct' exposure reading under a wide range of lighting conditions and with a variety of subjects. This is acceptable for the majority of picture-taking situations. But there are times when an adjustment to the correct exposure setting will produce a different and sometimes better result. Some experimentation and practice will show that for certain types of subjects the right amount of under- or over-exposure will affect the colors, contrast and even the mood of the shot. The greater the exposure adjustment the more dramatic the result will be.

▲ Photographing towards a light-source such as the sun normally requires some corrective exposure adjustment. Over-exposure in this situation calls for some skill at the printing stage, for a successful result.

Hints and tips

● Experiment with exposure adjustment, by shooting spare frames in an ordinary photographic situation.

● Taking an exposure reading from the bright parts of the scene will have resulted in dramatic under-exposure, and a totally different, moody effect.

▶ The original image was over-exposed, and the photographer gave additional over-exposure at the printing stage to produce this result.

PHOTOGRAPHER:
Robert Tran

CAMERA:
Nikon F2 with 105mm lens

FILM:
Fujichrome 100D

EXPOSURE:
$\frac{1}{125}$ second at f5.6

PURPOSE/CLIENT:
Portfolio

FILM

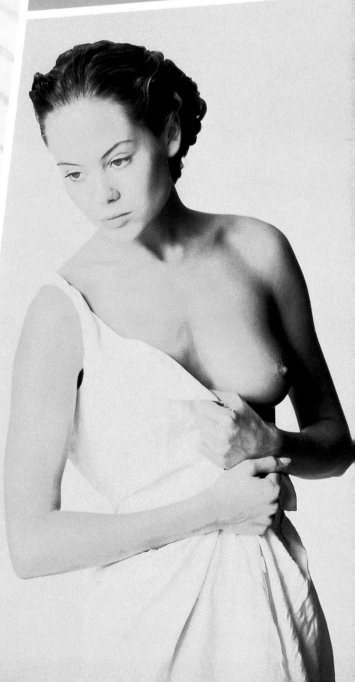

TUNGSTEN FILM

Tungsten film is normally used to avoid the orange-colored result that occurs when using daylight-balanced film in tungsten lighting.

If tungsten film is used in normal daylight everything in the scene will take on a blue coloring. This can be of use to the photographer who is looking for another special effect, and this color change doesn't even require a filter to produce the result!

The cool blue mood produced by tungsten film when used in daylight is highly effective with certain subjects. In this image it enhances the atmosphere of wealth and sophistication symbolized by the car and the woman.

▶ *The blue color cast in this outdoor shot was the result of using tungsten film, normally used for photographing in artificial lighting. The blue result is the way it copes with daylight.*

PHOTOGRAPHER:
Ben Lagunas

CAMERA:
Hasselblad with 80mm lens

FILM:
Kodak Ektachrome Tungsten EPT film

EXPOSURE:
⅛s second at f22

LIGHTING:
Daylight, supplemented by one Broncolor Strobe Pulso A2 (1600w/s) flash

PURPOSE:
Diva Collection

Hints and tips

● In an emergency tungsten film can be used in daylight with a pale orange filter to give neutral colors.

● It also copes well with color shifts that occur with extra long exposures.

▲ *Tungsten film is a non-standard film and is used here for the effect it produces when photographing subjects in daylight. The elements within the composition have been chosen to complement the color cast.*

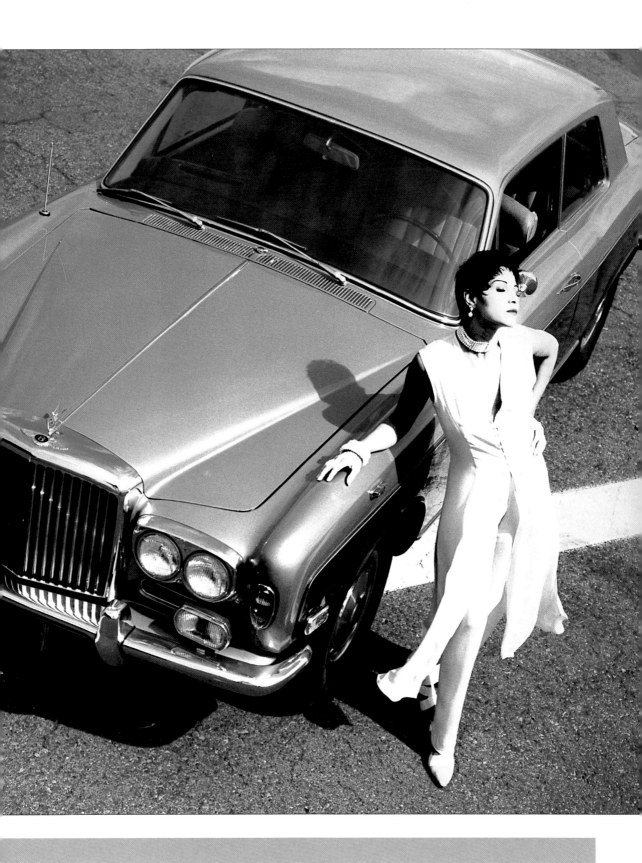

POLACHROME SLIDE FILM

One of the simplest ways to get a special effect result is to use a different film type. Polachrome, Polapan and Polagraph films – all by Polaroid and all 35mm – give distinctive and interesting results.

Polapan (ISO 125) is a medium speed b&w film with smooth grain, Polagraph (ISO 400) is a fast and grainy b&w film.

Polachrome (ISO 40) is a color slide film which is a favorite of photographers wanting to create a special effect. The colors have a quality that makes them stand out and there's a distinctive grain pattern. Polachrome (and Polapan / Polagraph) can only be developed using a Polaroid processing kit. This includes an auto (or manual) processor plus slide mounter and slide mounts.

Note that 35mm Polachrome, Polapan and Polagraph instant films are not DX coded. So DX coding cameras will automatically set them to ISO 100. You'll need to manually set the correct ISO speed, depending on the 35mm Polaroid instant film that's being used.

PHOTOGRAPHER:
Michèle Francken

CAMERA:
**Nikon F4
with 80–200mm zoom**

FILM:
Polachrome

EXPOSURE:
¹⁄₂₅ second at f8

LIGHTING:
Broncolor

PURPOSE:
For portfolio

▶ *The grainy characteristics of Polachrome can be used specifically for special effects subjects. But it is also effective with normal situations, the grain structure being noticeable with enlargement.*

▲ *A strong lighting set-up and high contrast help to enhance the properties of Polachrome film. It is an ideal film for photographers looking for a fresh approach to, say, fashion and portrait photography.*

Hints and tips

● The emulsion on Polachrome, Polapan and Polagraph slide films is more delicate than conventional film. Careful handling is required to avoid marking the surface.

One way around the problem is to make duplicates on conventional film, but note that the color characteristics of Polachrome may then be affected.

● A special built-in screen provides the colors for Polachrome. This needs to be allowed for when Polachrome images are to be used for publishing in newspapers, magazines, books or on printed posters.

GRAINY FILM

Film manufacturers try to produce film that has the smoothest grain because that is what photographers need for most of their work. But film that doesn't have smooth grain can produce an attractive effect which gives a different appearance to a photograph. The strong, distinctive characteristics of grainy film work well with portraits and nature subjects.

For this image the photographer has used Scotch 3M 1000, a fast, grainy color slide film. The lighting plus slight over-exposure has helped to make the colors look pale and the grain is more visible.

The original 35mm slide was cropped (see below) so as to emphasize the film grain.

PHOTOGRAPHER:
Naoki Okamoto

CAMERA:
Nikon F3 with 180mm lens

FILM:
Scotch 3M 1000

EXPOSURE:
⅟₆₀ second at f11

LIGHTING:
Small bank light 200w, backlight 200w

PURPOSE:
For editorial use in a magazine

▶ *Many films with high ISO speeds show noticeable areas of grain. The photographer made this effect even stronger by enlarging a small portion of the original image.*

▲ *A quick way to produce a grainy result with any film, even a smooth-grained one, is to enlarge a small part of the image area. This will produce a grainy result and at the same time a different composition.*

Hints and tips

● Push processing, which increases a film's speed, also makes it more grainy. The more stops a film is pushed, the grainier it becomes. But remember that colors will also become less stable.

● While fast film shows more grain than slow film, a slow film can also be used for grainy effects. Simply enlarge a small portion of the image area to make a slow film's grain more noticeable.

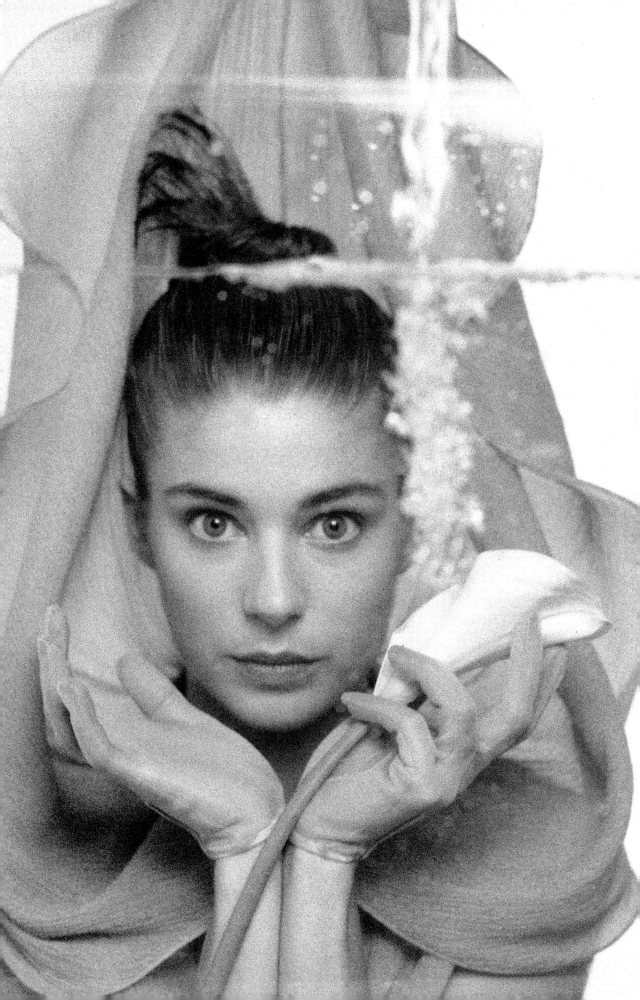

LITH FILM

A knowledge of how certain films and developers produce certain effects will be useful to the special effects photographer. It not only gives an idea of how a subject may look using a particular film, paper or developer, it can also be used as a basis for other special effects experiments.

The photographer of this shot knew that she wanted a grainy, high contrast result in black and white. So she chose a film that produces a grainy result. Then she processed it using a very high contrast developer called Kodalith developer. Finally she printed it onto lith paper, which also has very high contrast.

The result is an image that has very few areas of tone. The high contrast lith developer has reduced the grain of Tri-X film to distinctive black specks. The finished image suits the moody effect that the photographer wanted to produce.

▶ *The high contrast result and the gritty effect produced by the grain of the fast film provides the right setting for this moody portrait, which is part of a series.*

PHOTOGRAPHER:
Valerie Phillips

CAMERA:
**Hasselblad 500 CM
with 150mm lens**

FILM:
Kodak Tri-X

EXPOSURE:
$\frac{1}{25}$ second at f5.6

LIGHTING/TIME OF DAY:
Afternoon, northern light

PURPOSE/CLIENT:
**From personal series 'Girls
can say that'**

◀ *The angle of view, looking down onto the subject, plus the girl's crouched figure helped to create a dramatic composition. The only source of illumination was daylight coming through a window. This produced a high contrast result which was later enhanced using a high contrast developer. Alternatively, push-process film by 2 stops, then print on high contrast paper.*

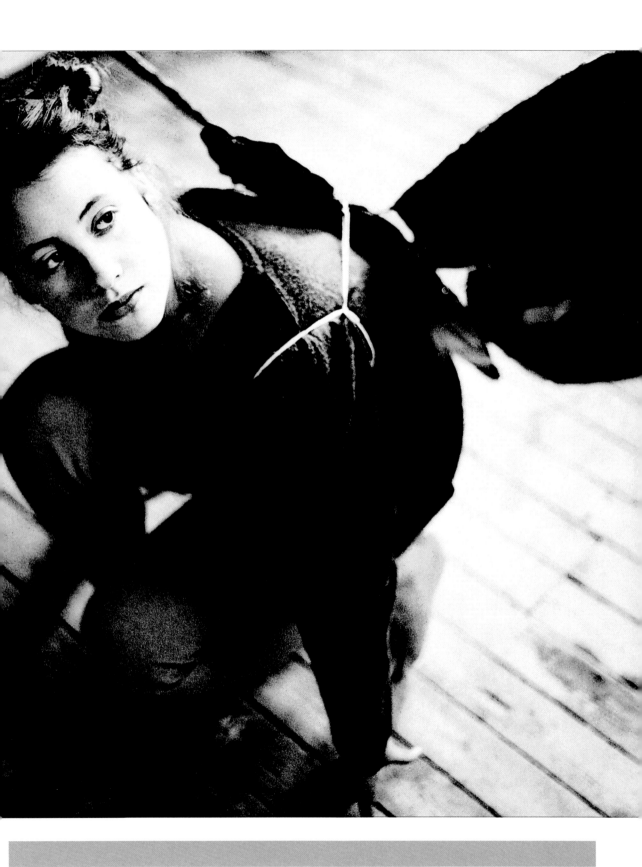

INFRARED FILM (BLACK AND WHITE)

One of the most popular ways to get a special effects result is by using black and white infrared film. This film is sensitive to normal light and infrared light. Subjects that give off strong infrared radiation, such as sunlit grass and trees plus light-sources such as lamps, will be recorded on film with a glowing halo around them. Images shot on b&w infrared film therefore have a distinctive appearance.

It's a special effects film that is often used for landscapes. The strength of the glowing effect can be altered by using special infrared filters. These range from pale yellow or orange types all the way to those that look black to the naked eye but produce the strongest infrared effect.

NB. The rays of infrared light focus at a point just beyond where normal visible light is focused on the film. So when focusing for infrared film use the infrared (IR) focusing mark on your lens. But if you also want to have sharp focus on subjects that are illuminated by normal lighting in the same scene then it's best to focus at a point somewhere between the IR mark and the point of normal focus.

▲ The shooting angle was chosen so that the light-source was included in the frame. The Kodak film used for this image is highly sensitive to infrared light waves. The photographer knew that the lamps would produce a glowing result when used with this film. There are also other special infrared filters (ie yellow and orange) which produce a less intense glow. Opaque filters enable infrared flash photography.

PHOTOGRAPHER:
Mark Thayer

CAMERA:
Nikon F4

LENS:
35-70mm

FILM:
Kodak High Speed infrared b&w film

EXPOSURE:
1/125 second at f11 with No. 25 red filter

LIGHTING:
Studio strobes

PURPOSE:
Used as 1x2m mural for Boston Scientific Corporation

▲ *The main effect produced by b&w infrared film is a glow, especially if there is illuminated vegetation in the shot or, as here, a bright light-source.*

Hints and tips

● As infrared film is more sensitive to light-fogging than normal film, it needs extra precautions when handling and processing. It's best if loaded – and un-loaded – in a darkroom or heavy-duty changing bag in a darkened place.

● It has a delicate surface which can get scratched easily with hasty or care-less handling.

● To see the glowing effect at its best take photographs in bright or highly reflective lighting.

HIGH CONTRAST WITH BLACK AND WHITE FILM......

There are several ways to get a high contrast result using black and white film. The photographer could use high contrast lighting. Another method is to use a lith film which produces pure black and white areas only, with no tones.

Yet another method is to use a combination of a pushed film with appropriate filters, as in the image shown here. Three factors contribute to the high contrast effect:

● pushing film, which increases the contrast.

● a red filter, which produces high contrast when used with b&w film.

● a polarizing filter, which darkens a blue sky and makes clouds stand out in strong contrast.

(The increase in visible grain is a by-product of pushing the film, and gives a distinctive quality to the image. But there are alternative fast black and white films that can be used to produce smoother grained high contrast results.)

Using contrast In photography and print-making high contrast is often regarded as a factor that needs to be kept under control. But it can be used as an asset in normal as well as special effects photography. High contrast makes certain parts of a scene stand out dramatically. A low-contrast scene or subject can be improved by use of high contrast lighting or a film that gives a high contrast result.

Filters As well as lighting and film, contrast (for black and white film users) can be increased by the use of filters. Red, orange, yellow and green filters provide varying contrast results that are most noticeable with skies, landscapes and portraiture. Note that exposures will need to be adjusted accordingly eg. a red filter, which produces the highest contrast, needs an exposure compensation of three stops.

PHOTOGRAPHER:
Shahn Rowe

CAMERA:
Nikon FE2 with 180mm lens plus polarizer and red filter

FILM:
Kodak Tri-X rated at ISO 1000

TIME OF DAY:
Late afternoon

PURPOSE:
Used in photographer's Wildlife portfolio

▶ *Kodak Tri-X film, pushed to ISO 1000, has provided a range of fast shutter speeds, ideal for photographing action. The ISO 1000 produced a high contrast result, further increased by use of a red filter.*

▲ *The top part of a rotating polarizer, when turned, can be used to dramatically contrast in a blue sky.*

Hints and tips

● Areas of white in the scene give added impact to the high contrast effect.

● A consequence of high contrast in a pushed film is a less smooth range of tones in the image.

POLAROID *OHP* SLIDE FILM

Polaroid's range of instant films – in color as well as black and white – produces a variety of interesting characteristics that can be exploited by special effects photographers.

Polaroid Type 691 film, used here, is intended for use with overhead projection systems. It has a size of 3¼ x 4¼ in. and with adequate sharpness for projection purposes. As with most of the company's professional films it needs to be peeled apart when developing is done in order to produce the finished image.

Although the film base is quite thick the emulsion itself is easily damaged and needs delicate handling. As there were some damaged areas in the original emulsion the photographer had to make a digital copy which was then corrected. Apart from this no other manipulation was carried out.

The light fall-off effect ie vignetting is a characteristic of the lens in the camera that was used to photograph the image. Older cameras that were once used for snapshots sometimes produce vignetting.

PHOTOGRAPHER:
Naoki Okamoto

CAMERA:
Polaroid

FILM:
Polaroid Type 691 OHP

EXPOSURE:
Not known

LIGHTING:
400w studio flash used as front light with umbrella, 400w studio flash aimed at background

PURPOSE/CLIENT:
For fashion magazine

▶ *Polaroid's instant OHP film, while suitable for projection purposes, has a soft edge that is especially suited to some types of portraits.*

▲ *The photographer chose the subject, costume, hairstyle and lighting set-up to suit the qualities of Polaroid's OHP film. It has high contrast, and the selected lighting needs to compensate for this.*

Hints and tips

● As these films are most vulnerable when being peeled apart, this procedure needs to be carried out with some care.

● Digitizing images that have been taken on Polaroid OHP film ensures the originals are safe. It is also a way to make corrections to damaged areas and, if required, to make color adjustments.

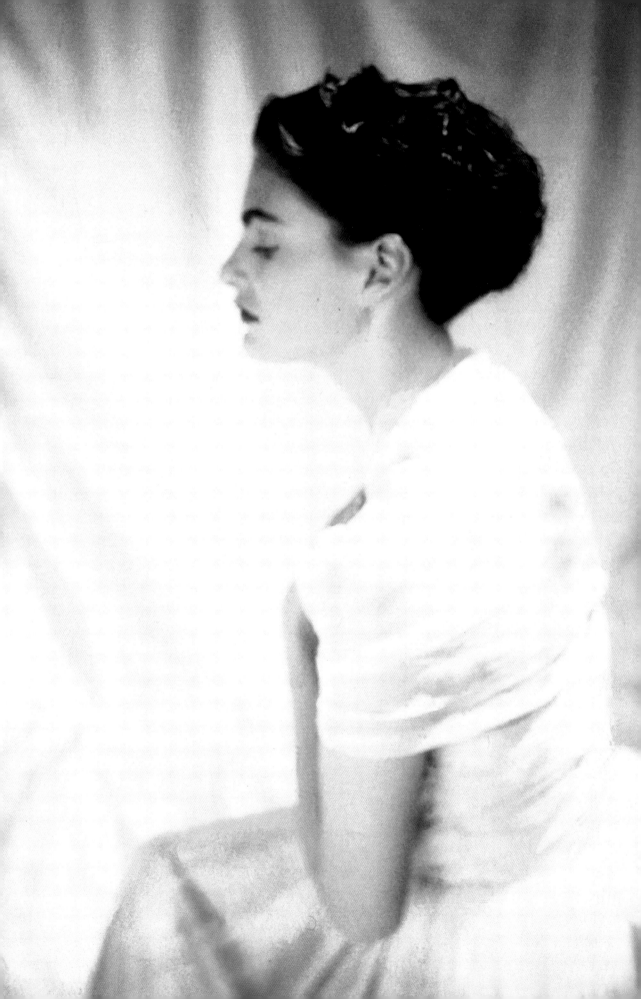

POLAROID POLAPAN BLACK AND WHITE SLIDE FILM

Because color images are in such wide use a black and white image, especially in an advertisement or in a selection of images, will immediately stand out. The distinctive characteristics of Polaroid's Polapan film will make monochrome images even more eye-catching.

The smooth tonal range and high sharpness of this film make it compete favorably with b&w images that have been produced by conventional means. A bonus is that, as a Polaroid instant 35mm film, it can be developed in 60 seconds at normal room temperature. So it can be used not just for tests but it can be mounted and, if required, then used in a slide presentation.

PHOTOGRAPHER:
Michèle Francken

CAMERA:
**Nikon F4
with 80-200mm zoom**

FILM:
Polapan 35

EXPOSURE:
1/125 second at f8

LIGHTING:
Broncolor

PURPOSE:
For portfolio

▶ *Polaroid's Polapan has a distinctive appearance, with good sharpness and tonal range. As a slide film it can be used for projection or printing.*

Hints and tips

● Its emulsion is delicate and needs careful handling. Valuable Polapan originals can be duplicated on to Polaroid instant print or other films for safe-keeping.

● A duplicate slide of a Polapan image so created can then be used in slide sandwiching, with no risk to the original.

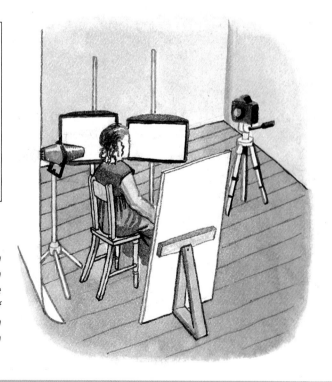

▶ *The image required a simple lighting set-up which emphasized the model's pose and picked out the details of the dress. Polapan's medium contrast result works well in even lighting.*

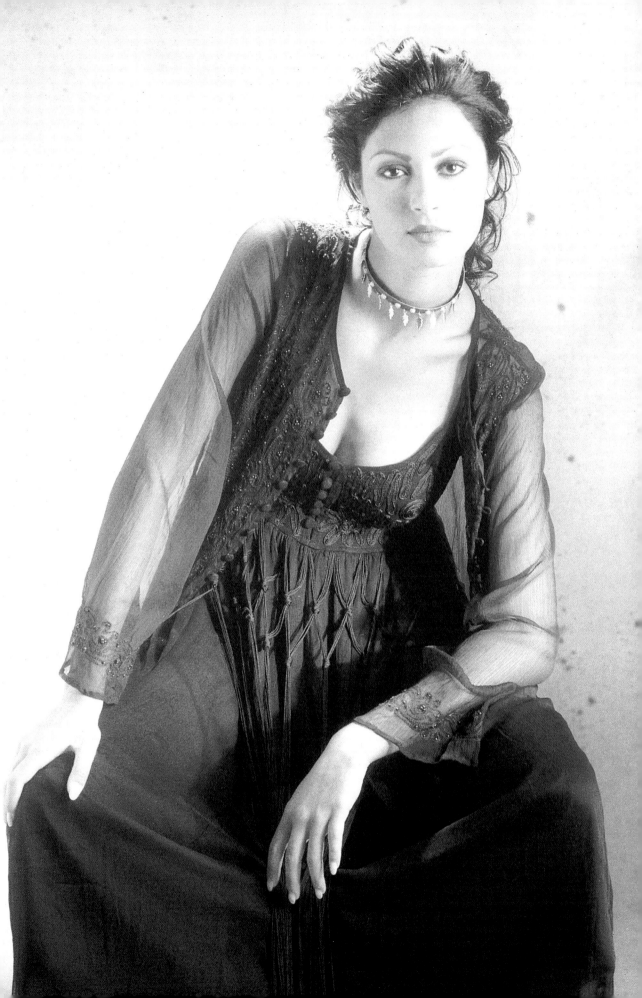

IMAGE TRANSFER

The image transfer technique produces a result that can look almost like a painting. It's possible to create striking images with most subjects using this method. Image transfer works well with portraits, flowers, landscapes and old architecture.

You will need:

A pack of instant peel-apart film, a slide printer, an evenly exposed slide, a roller, water-color paper or a water-absorbing paper used in water-color painting, and a bowl of water.

PRODUCING AN IMAGE TRANSFER

1. Soak the paper in the water for 30 seconds, then take it out and wipe off the excess water.

2. Place the chosen slide in the slide printer. Set the printer to the 'average exposure' setting, then press the button. (Alternatively an enlarger can be used.)

3. Pull the film out. After just 10 seconds peel the film apart. Throw away the positive print and immediately place the negative face-down onto the sheet of pre-soaked paper.

4. Move the roller (or hand) evenly over the entire back of the negative area. Then, depending on the film type used, wait for 90 seconds or 2 minutes.

5. Carefully peel off the negative from the paper's surface. On the paper's surface will be the transferred image.

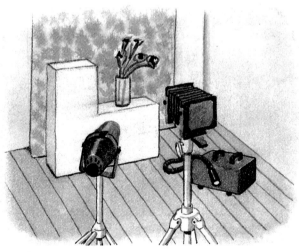

▲ The image transfer began life as a conventional still life shot, though the subject was specially chosen for the effect. It was then put through the image transfer process to produce the result opposite.

PHOTOGRAPHER:
Charlie Lim

CAMERA:
**Sinar P 5x4
with 240mm lens**

FILM:
Polacolor 100

EXPOSURE:
B setting f22

LIGHTING:
**Hosemaster light painting
device**

PURPOSE:
For client's calendar

▲ Image transfer produces a distinctive and alternative image to the photographic original that it came from. The result is due to the effect of the rubbed-down emulsion on the water-color paper.

CROSS-PROCESSING

Some of the best special effects are produced when breaking the rules. For instance color slide film should normally never be processed in chemistry that is used for color print films. And color print film should never be processed in slide film chemicals.

Yet this wrong procedure is well worth trying as a special effects technique. The results, although producing colors that are inaccurate, gives a completely different type of result from that of a normal color slide or a color print. The effect can be subtle or strong, depending on the colors and lighting that are used.

The photographer took straight shots on color print film, then put it through E6 processing at +5 stops.

PHOTOGRAPHER:
Frank P. Wartenberg

CAMERA:
**Mamiya RZ67
with 380mm lens**

FILM:
Kodak VHC

EXPOSURE:
f5.6–f8

LIGHTING:
**Briese Flashlight 2.5Kw
HMI lighting**

PURPOSE/CLIENT:
Front cover of Fotomagazin

▶ *Cross-processing has produced a subtle yet distinctive effect that would be difficult or impossible to re-create using other techniques. Add to this the right subject, lighting and composition and the result is a breathtaking image.*

Hints and tips

● Photograph originals that have a wide range of bright colors. The cross-processing technique will dramatically alter some of these colors yet leave others unaffected.

● For some eye-catching results try sandwiching a cross-processed slide with a normally processed slide.

◀ *This was the simple set-up for the cross-processed image opposite. At the heart of most photographic special effects is a knowledge of the basics, such as adequate lighting and simple, effective composition.*

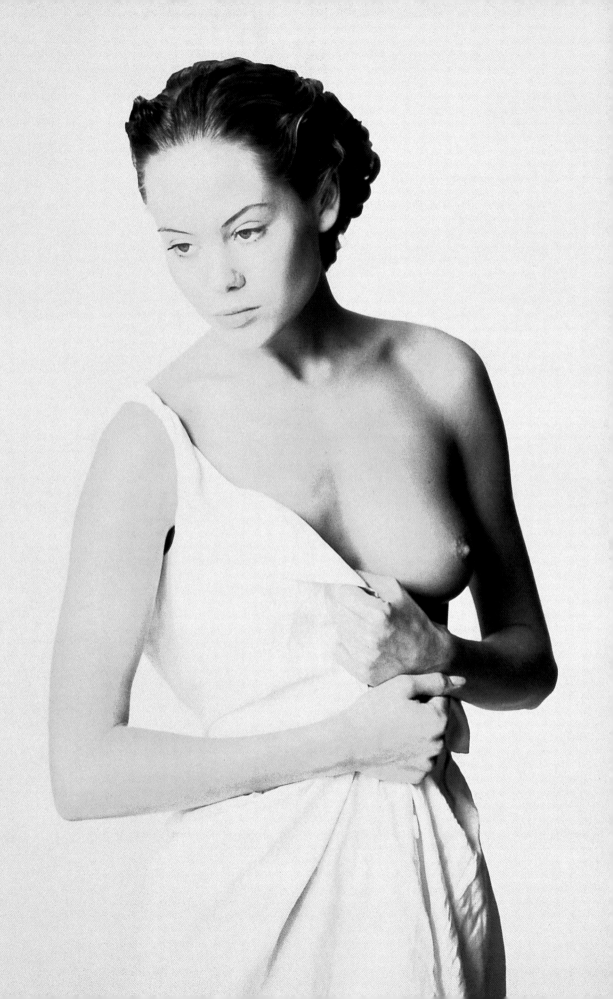

SLIDE SANDWICH

Sandwiching two slides together is a quick way to create a new image. To start off you could try combining a silhouette of a tree outline or a window frame, with a simple color subject such as a pattern of flowers or leaves or sky.

NB. Make sure that the slides you're combining are slightly over-exposed. Normal and under-exposed slides, when combined, are likely to create a dark image with low contrast, as well as dull colors.

In the image on the right the photographer took two separate photographs of a model whose face was covered with colored powder. He sandwiched them together but slightly out of register so that he created a swirling moire effect with the colors. He then photographed the result. Finally, on a computer, he made some minor adjustments to the mis-register.

Hints and tips

● Natural subjects such as leaves and flowers have colors and shapes that combine well in slide sandwiches. Man-made objects and architecture generally work well with strong, bright colors.

● Try sandwiching two over-exposed slides of the same subject exactly together, and the resulting image will look normally exposed and with twice the intensity of color.

● If you have a few frames left on a roll of film you could use them to photograph subjects especially for future slide sandwiches.

▶ This image was created by sandwiching two slides of the same subject together as one picture. But instead of the slides exactly overlapping, one was positioned slightly out of alignment with the other.

PHOTOGRAPHER:
Stefano Zappalà

CAMERA:
Sinar 10x8 with 360mm lens

FILM:
Kodak EPR 64 and Kodak EPY 64T

EXPOSURE:
⅟₆₀ second at f45

LIGHTING:
Broncolor 6000 Torcia

PURPOSE:
Portfolio

▲ Some of the best special effects are produced by simple rule-breaking as well as experimentation. The photographer in this case tried simple mis-alignment of the two slides for the required result.

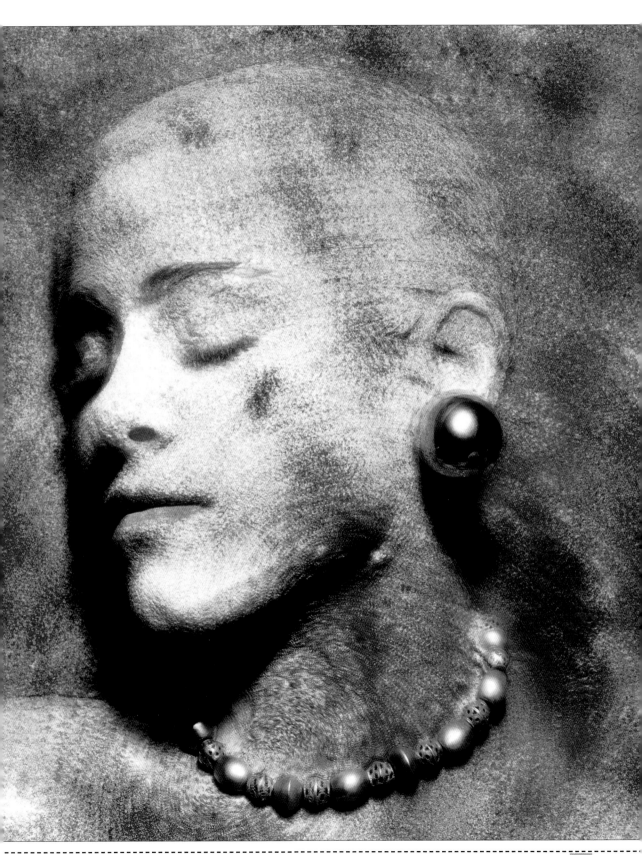

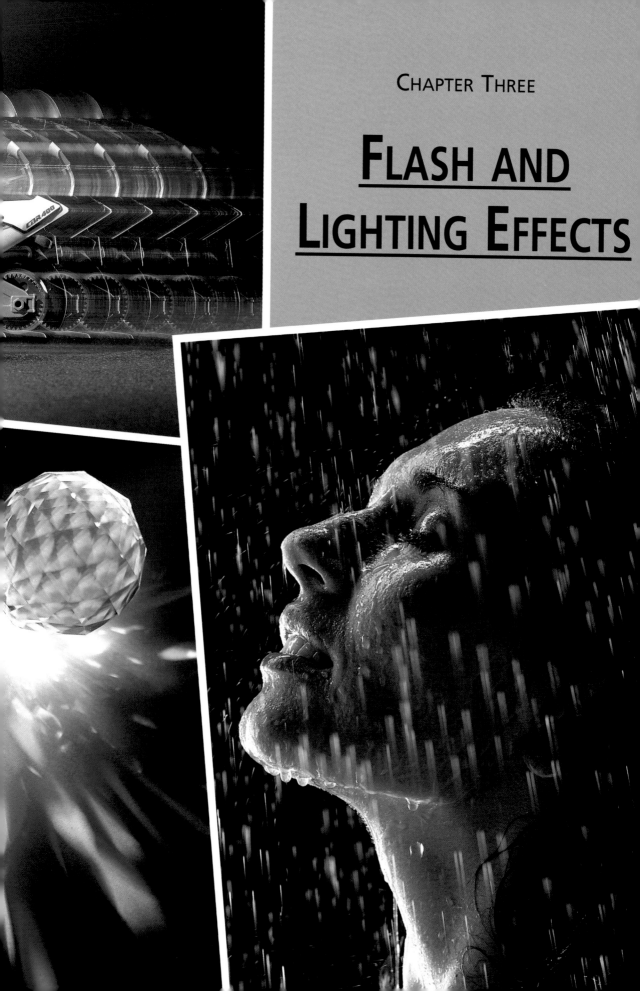

FLASH AND LIGHTING EFFECTS

FREEZING MOVEMENT, WITH FLASH ----------------------------------

Flash can often be used instead of fast shutter speeds to freeze subject movement. And flash duration can be quicker than the fastest conventional shutter speeds.

The photographer used flash to freeze the water droplet in the glass. This is how he did it:

Droplets of water, from an old-fashioned camera bulb release, were released into the glass at the same time as the flash was triggered by the camera's shutter button.

A shutter speed of ⅟₆₀ sec was chosen because the photographer discovered that this was the length of time it took for the droplet to fall.

A large Wafer Striplight produced soft, diffused general illumination. It was positioned overhead in such a way that its light hit the rim of the glass but not the front.

Several shots (30–40!) were taken until the photographer was sure that the droplet had been photographed at the right position.

PHOTOGRAPHER:
Peter Ericsson

CAMERA:
Hasselblad 553 ELX with Sonnar CF f5.6 250mm lens

FILM:
Agfa RS 100

EXPOSURE:
⅟₆₀ second at f5.6

LIGHTING:
Wafer Striplight positioned above the glass. And one Bowens Travelite 3000 flash unit, at lowest power ratio setting

PURPOSE:
For water purifier company, to illustrate the theme of 'purity'

▶ *The simplicity of this image and the almost monochrome result provide the ideal setting for the water droplet and the idea of 'purity'.*

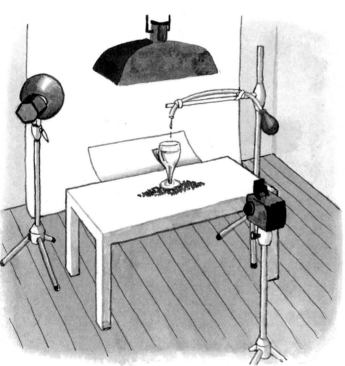

▲ *Moving water is a very difficult subject to capture with success, either in a studio or outdoors. The photographer needed the above set-up – and lots of patience! – to produce the result opposite.*

Hints and tips

● The lowest power ratio setting on your studio flash will give the shortest duration of flash output.

● Carefully positioned reflectors will help to emphasize the shape of a transparent object such as a wine glass. The reflectors also help to outline the shape of the droplet.

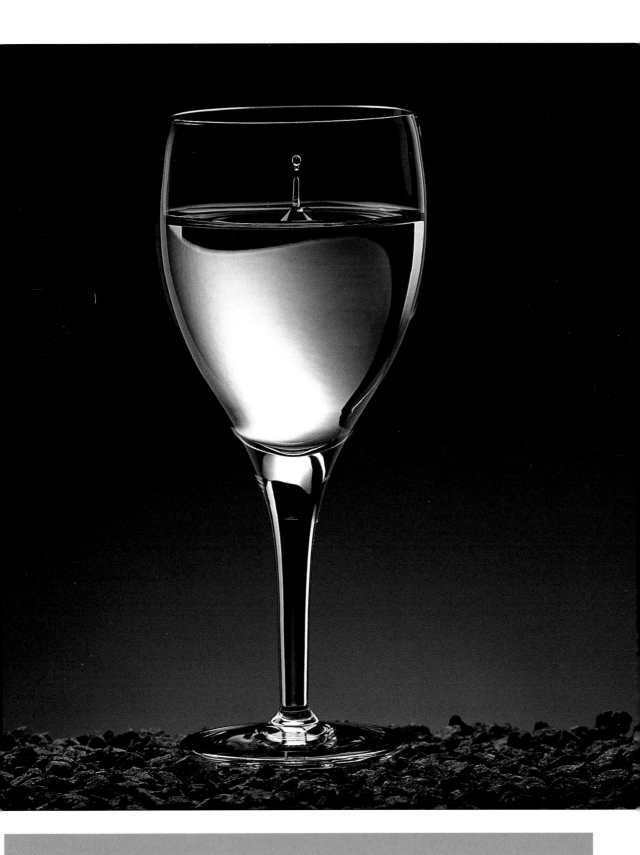

FREEZING MOVEMENT

The movement of an object can be frozen in time by the appropriate shutter speed. The shutter speed that is used depends on the speed of the object that's being photographed.

A spray of water coming out of a shower hose is faster than a regulated droplet of water falling into a glass. So a faster shutter speed is needed – but how fast? For the image on the opposite page a shutter speed of ½₅₀sec has captured the movement of the water droplets that occurred during that fraction of a second. This is shown by the streaks that they have created.

A faster shutter speed would have made the streaks of the water droplets much shorter.

A much slower shutter speed would have made the streaks longer and the model wouldn't have been seen so clearly.

PHOTOGRAPHER:
Patrick Blake

CAMERA:
**Mamiya RZ67
with 110mm lens**

FILM:
Kodak Ektachrome 64

EXPOSURE:
½₅₀ second at f8

LIGHTING:
**Strobe Equipment S60
strip lights, each 2000
Joules full power**

▶ *The shutter speed has transformed the water from the shower hose into short streaks. A full-length portrait was tried first. This framing was the best.*

▲ *The model needed to be illuminated in such a way that the highlights on the water droplets were seen clearly in relation to her face. Polaroid tests were needed for this and to find the best shutter speed.*

Hints and tips

● Using a similar set-up to the above, the length of the water droplet streaks can be varied purely by choosing different shutter speeds.

● The model stood on polythene sheeting which was placed so that the water was drained safely away from the studio's electronic equipment.

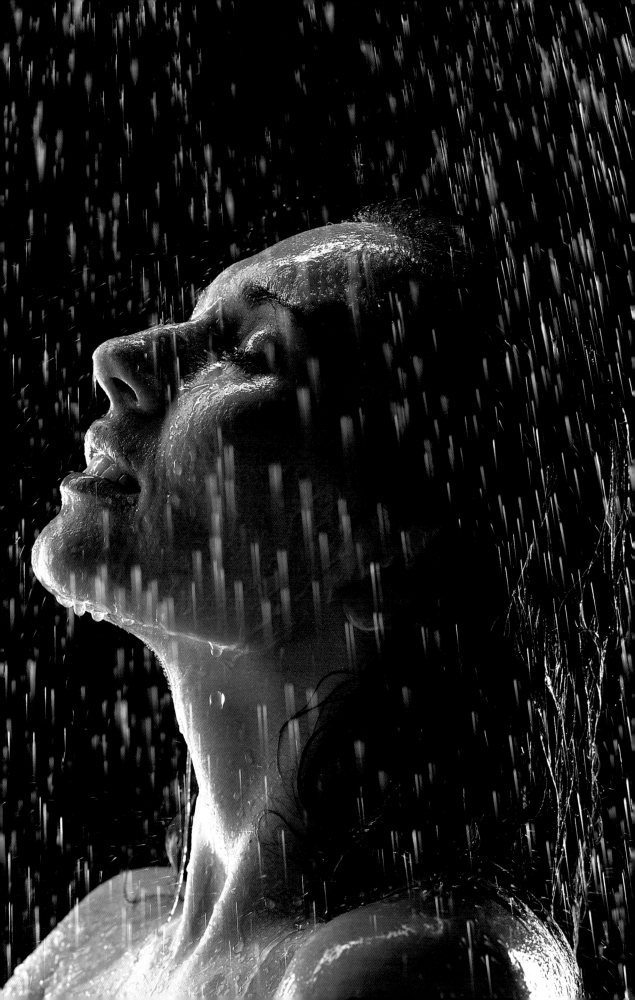

FLASH/SLOW SHUTTER DOUBLE EXPOSURE

Double exposures can be made of two still objects. A double exposure can also be made of two moving objects, even if they are moving at different speeds.

The first part of this double exposure used a very slow shutter speed of ⅛sec to create the soft blurring result in the water. The second part of the exposure was a flash shot used to freeze the falling leaves in mid-air. The combined double exposure therefore shows slow shutter speed (giving a blur effect with the moving water) as well as flash (freezing the movement of the falling leaves), both effects on the same frame of film.

A neutral density (ND) filter was used to produce the very slow shutter speed for the first part of the image. ND filters reduce exposure.

For the second exposure the flashes were positioned carefully. An assistant then threw leaves down onto the water. The final image was the result of more than 30 frames!

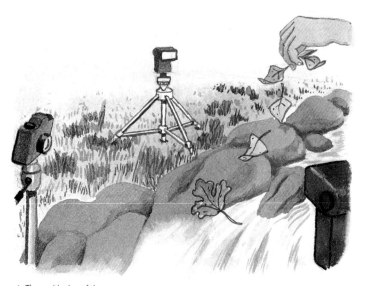

PHOTOGRAPHER:
Luciano Schimmenti

CAMERA:
**Nikon FM2
with 135mm Nikkor**

FILM:
Kodak Ektachrome 64

EXPOSURE:
**⅛s second at f4
(with ND filter)**

LIGHTING:
Three flashguns

TIME OF DAY:
p.m.

PURPOSE/CLIENT:
Portfolio

▲ *The positioning of the accessory flash units on stands allowed the assistant to drop the leaves into the water. This was a task that had to be repeated several times!*

▶ *The high speed of the flash burst has frozen the falling leaves in such a way that they almost look as if they have been stuck onto the scene.*

Hints and tips

● With a tricky double exposure like this it's best to take a series of shots. And, everything else being equal, using more than one film will increase the chances of getting a satisfactory result.

● Remote flash slave cells are an alternative to using cables, especially useful for outdoor photography.

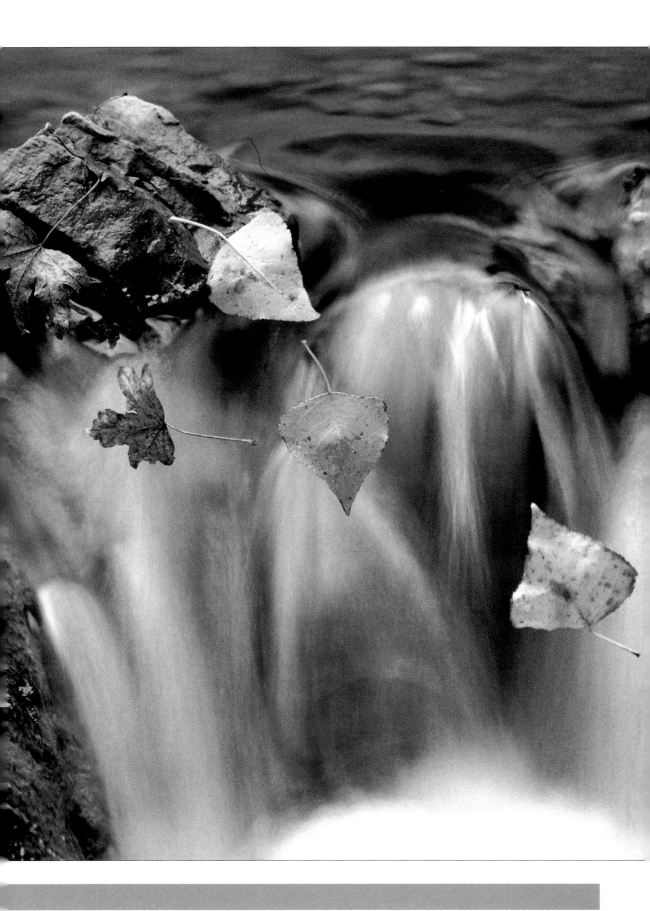

FLASH MULTIPLE EXPOSURES

One of the most practical uses of multiple exposures with flash is for creating secondary images. This effect can be used to give an impression of movement and speed.

For this it's important to have a studio flash with a range of variable power settings.

The image opposite was created from eight separate exposures. The first exposure was a straight shot of the toy motorcycle on a metal surface. For each of the other seven exposures the motorcycle was moved to the right in equal stages. At every stage a shot was taken, with the lighting being reduced (by ⅓ of a stop) each time, by using the variable power ratios of a special strobe unit.

Small pencil marks were placed on the metal sheet as a guide for positioning the bike for each exposure.

While the model was being moved a black card was placed over the camera lens. This was to make sure that the hands of the photographer's assistant, who positioned the motorcycle for each stage, wouldn't be seen on the film.

PHOTOGRAPHER:
Patrick Blake

CAMERA:
Sinar 5x4 with 210mm lens

FILM:
Kodak Ektachrome 64

EXPOSURE:
Fixed aperture of f32

LIGHTING:
One main light for the set plus one Strobe Equipment City 5000 pack for the secondary 'speed' images

PURPOSE:
Tomy Toys

◄ A main light provided the overall lighting for the set. In addition, a special rapid-pulsing strobe flash was used for each stage, to give an impression of subject movement.

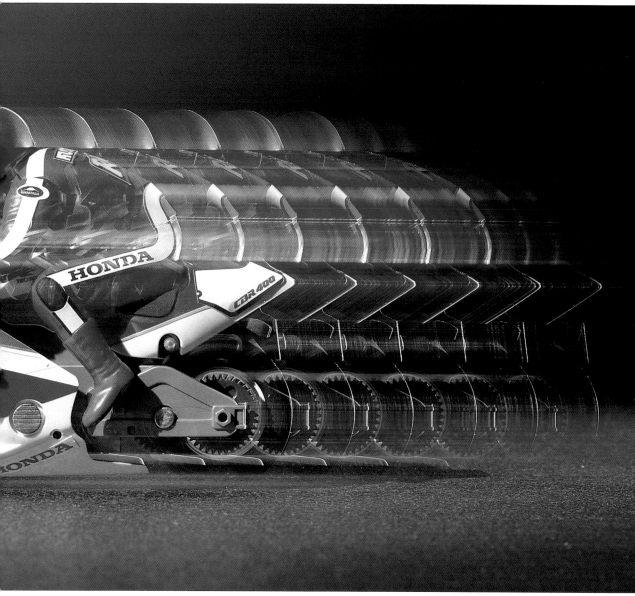

▲ *Several exposures with strobe flash were made, with the toy motorcycle placed at different positions along a straight line.*

Hints and tips

● An image like this takes time and careful planning. You need to work out all the details, ie lighting and props, long before you start the photography.

● Multiple exposures using flash are best done in a studio, where the elements are in a controllable situation.

● The surface the object is on must not be adjusted once set, so that all the secondary images will be at the same height. Also, it's best to adjust the exposure via the lighting and not the aperture, so as to lessen the risk of accidentally moving the camera.

RING-FLASH

One of the most important aspects about using flash is controlling the shadows and where they fall. This can be done by using reflectors or devices that attach to flash such as diffusers, barn-doors and snoots.

An alternative is to use a ring-flash. This device consists of a circular flash-head that fits around the front of the lens. A ring-flash provides all-round illumination, so that there is no strong side-lighting. The result is an image that shows soft-edged, virtually non-existent shadows.

The even lighting of a ring-flash is perfectly suited to certain types of portraiture and nature photography and for close-up subjects that have plenty of detail.

Andy Cameron used it to photograph these poppies against the Cornflower Blue background paper. He inserted thin wire inside the stems of the poppies to keep them rigid.

The distance of 1m that he was photographing at has emphasized the flower details and the texture of the background paper.

PHOTOGRAPHER:
Andrew Cameron

CAMERA:
Mamiya RB67 with 127mm lens plus No. 1 extension tube

FILM:
Fujichrome Velvia

EXPOSURE:
$\frac{1}{125}$ second at f22

LIGHTING:
Alfa 5000 ring-flash unit

PURPOSE:
Portfolio, and displayed at an exhibition

▶ *Ring-flash produces images with virtually no shadows. Its flat, even lighting is ideal for close-ups of detailed subjects like flowers.*

▲ *The photographer chose a shooting distance that would produce a tightly composed image, to make the most of the main colors of the poppies and the background. A small aperture was used.*

Hints and tips

● The closer the subject is to the background, the lesser the shadows.

● Most ring-flashes have low power output and work best at close distances. However, there are also more powerful and expensive custom-built ring-flashes available that can be used for subjects such as small group portraits.

● Ring-flashes are available for use with 35mm SLRs as well as for medium format cameras.

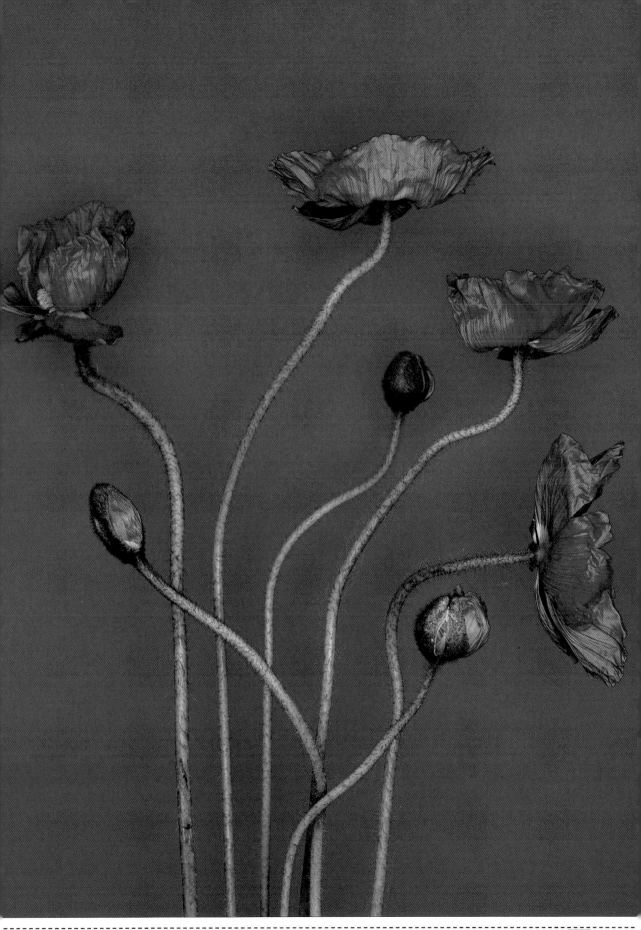

LIGHT-PAINTING

Light-painting can be done with an ordinary torch. But a specially made light-painting tool is better because it is color-corrected.

The beam from the light-painting tool is aimed at dark areas that need to be lightened. Because it may take some time to effectively 'paint' the scene with light, it needs to take place during a long exposure.

Young Soo Kim created this image by using two exposures. The first used conventional studio lighting. For the second exposure he switched off the studio lighting and used only the light-painting tool. He carefully filled in some of the shadow areas, working from the same direction as the fill-light, so that the result looked natural.

▲ *It's important to have a clear idea of the areas that need light-painting, and the areas which have already been lit by the moving light. The above test print clearly shows the areas of shadow that need filling, as well as the general exposure adjustments that will be needed for the shot. And a stable, static set-up is required for successful light-painting, as exposures may last for several seconds or even minutes.*

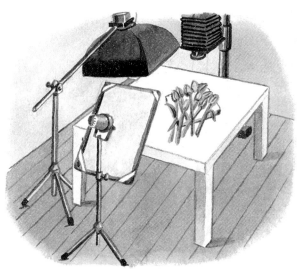

◄ *The overhead camera position gave the photographer plenty of free space to move around the subject with the light-painting tool.*

PHOTOGRAPHER:
Youngsoo Kim

CAMERA:
Horseman 5x4 with 240mm lens

FILM:
Fujichrome Velvia

EXPOSURE:
1st: f16 for studio flash units. 2nd: f16 for light-painting

LIGHTING:
Two Speedotron studio flash units, one Wafer medium softbox, Calumet Spot Lite (used as fill-light) with 'leaf' pattern filter, Light FX light-painting system

PURPOSE:
1995 Calendar for Esquire shoe company, Korea

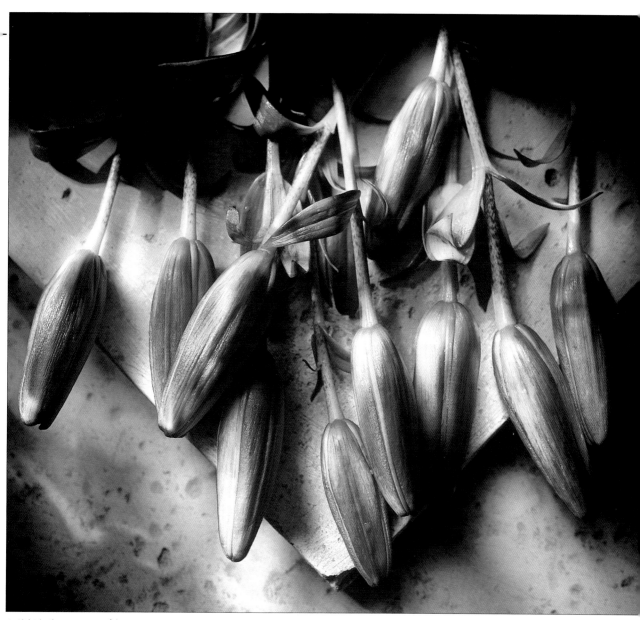

▲ Light is the most powerful tool available to the photographer of special effects. A light-painting tool, such as the one used for this image, provides a way to create a particular effect and mood.

Hints and tips

● With the above set-up a good working distance is around 10 to 20cm from the subject.

● At f11–f16, 5 to 10 seconds is usually sufficient for each area.

● Do a few trial shots first, using instant film, to discover where to paint the light and how much is needed for a particular area.

HOME-MADE LIGHT-PAINTING

The technique of light-painting is not a new one. In fact there is a range of commercially available equipment specifically for it.

A light-painting device or light-brush is, at its simplest, nothing more than a torch with a concentrated and powerful beam. Other devices can be used instead, such as an ordinary torch or even the light beam from a slide projector lamp.

Müfit Çirpanli used a pair of slide projectors and a torch with a small but powerful beam to create this image. The shutter was kept open after the flash burst to allow enough time for selective lighting of parts of the scene, using these devices.

Unlike a proper light-painting set-up the illumination in this image was not color-corrected, so the resulting colors have a warm ie yellow-orange appearance. However, the color cast perfectly suits this Christmas scene, giving a general impression of warmth and comfort.

PHOTOGRAPHER:
Müfit Çirpanli

CAMERA:
Cambo 5x4 SCX monorail and Rodenstock 210mm lens fitted with soft focus filter

FILM:
Kodak Ektachrome 100

EXPOSURE:
Several seconds at f16

LIGHTING:
Large softbox with 1000w/s flash. Also, two slide projectors and a small torch

PURPOSE:
Pabetland department store

▶ *The photographer knew beforehand the warm result that his invented light-painting set-up would produce, especially when used with daylight balanced film.*

▲ *It is worth positioning and re-positioning all the elements of the shot for the best arrangement of objects and lighting. Polaroid tests are ideal, especially if you're trying out experimental techniques.*

Hints and tips

● Be prepared for color casts if using a slide projector or a torch as a light-painting tool when using daylight- balanced film. These casts can be corrected by using an appropriate filtration. Alternatively, they can be kept as part of the image effect.

● As well as the projector's illumination, a projected slide with a colorful scene or pattern can be used as part of the background of the image.

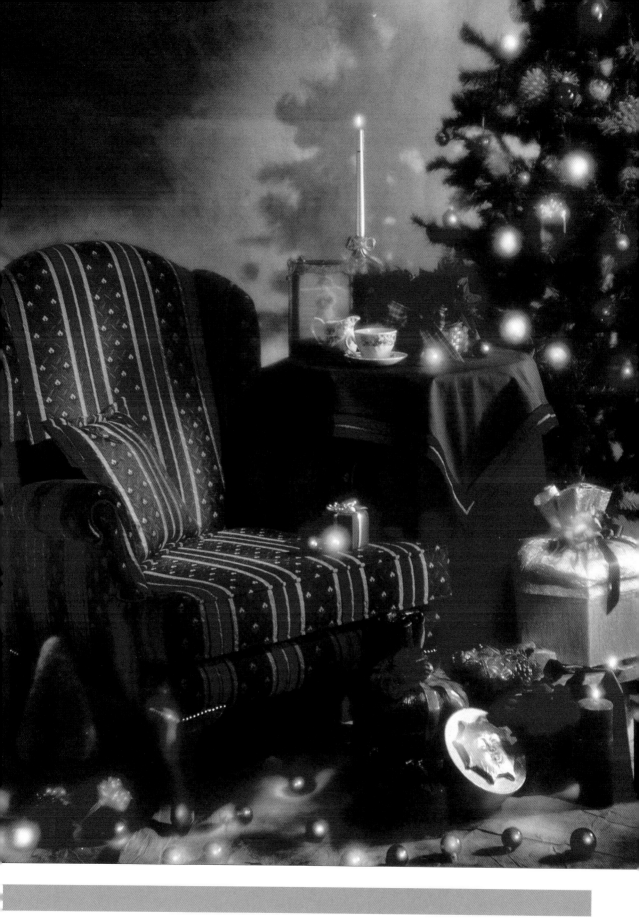

NARROW BEAM LIGHTING

A single narrow light-source can be used to illuminate a small subject (or subjects) in a darkened studio. Like the spotlight in a theatre it can make the subject stand out dramatically from the dark surroundings.

When the subjects are transparent, like the two crystals shown opposite, the light spilling through them creates additional impact. The light-source was a light-painting tool which gave a narrow beam of strong illumination. An alternative is a torch or a studio light with a very narrow snoot.

If the same scene had been shot with normal all-over lighting the result would have been completely different and less dramatic.

▶ *Glass is one of the most difficult subjects to illuminate. Here the light-source was a single beam. The light spilling through the glass has become part of the image.*

▲ *Without the darkened room the effect of the rainbow highlights would have been lost or, at best, weaker. The angle of the light-source is important too. The chosen position has effectively spread the rays.*

PHOTOGRAPHER:
Raymond Tan

CAMERA:
Mamiya RB67 with 180mm lens plus extension tube No. 1

FILM:
Fujichrome Velvia

EXPOSURE:
30 seconds at f5.6

LIGHTING:
Single beam from light-painting tool

PURPOSE:
For a client

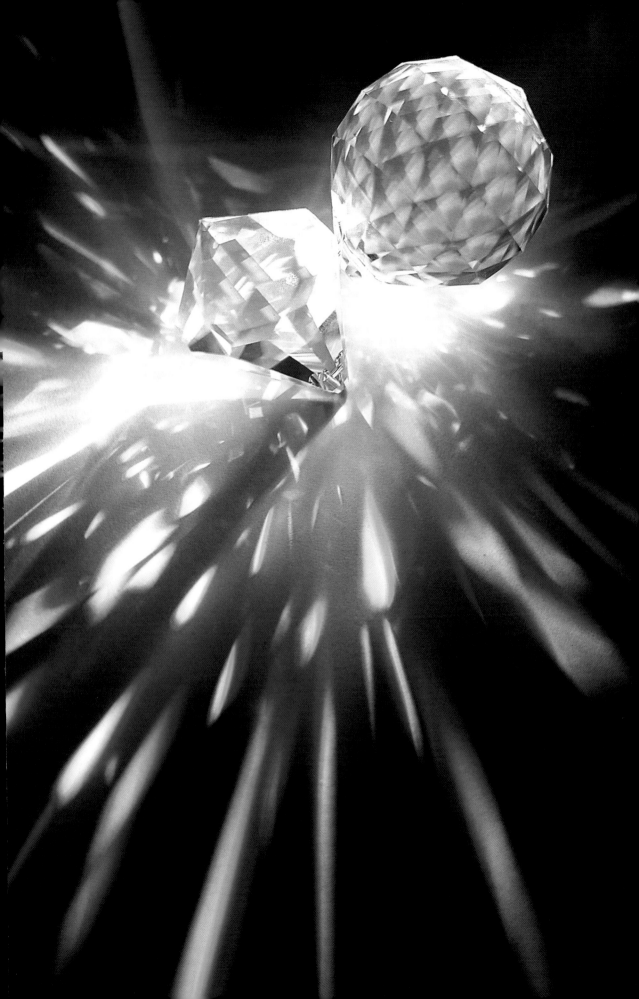

MULTIPLE FLASH

The model was in a completely darkened studio. The studio flash was then fired 10 times and throughout this period the model had to remain perfectly still. With the high power studio flash that was used the flash recycling times were very fast. The total exposure time was several seconds.

There was some subject movement during this time, especially noticeable in areas around the body outline. Yet this effect helps to give the image its unusual quality.

NB. The grainy result is not because of the technique used but is an important and useful characteristic of the film itself – Polaroid Polagraph, an ISO 400 instant black and white slide film.

Hints and tips

● A powerful studio flash is best for this technique. A portable flashgun, even if powerful, will not be able to deliver the required fast flash recycling times over a long period.

● During exposures that last several seconds a comfortably seated subject will be able to stay still longer than a standing subject.

▲ The studio flashes were placed in a semi-circle to give all-around illumination. The model selected a comfortable posing position but the long exposure still produced some body movement.

▶ Flash has endless possibilities for special effects use. This image was the result of 10 separate flashes plus accidental body movement by the model.

PHOTOGRAPHER:
Frank P. Wartenberg

CAMERA:
**Nikon FM2
with 105mm Nikkor lens**

FILM:
Polaroid Polagraph

EXPOSURE:
f5.6–f8

LIGHTING:
Briese Flashlight

PURPOSE/CLIENT:
Grundig

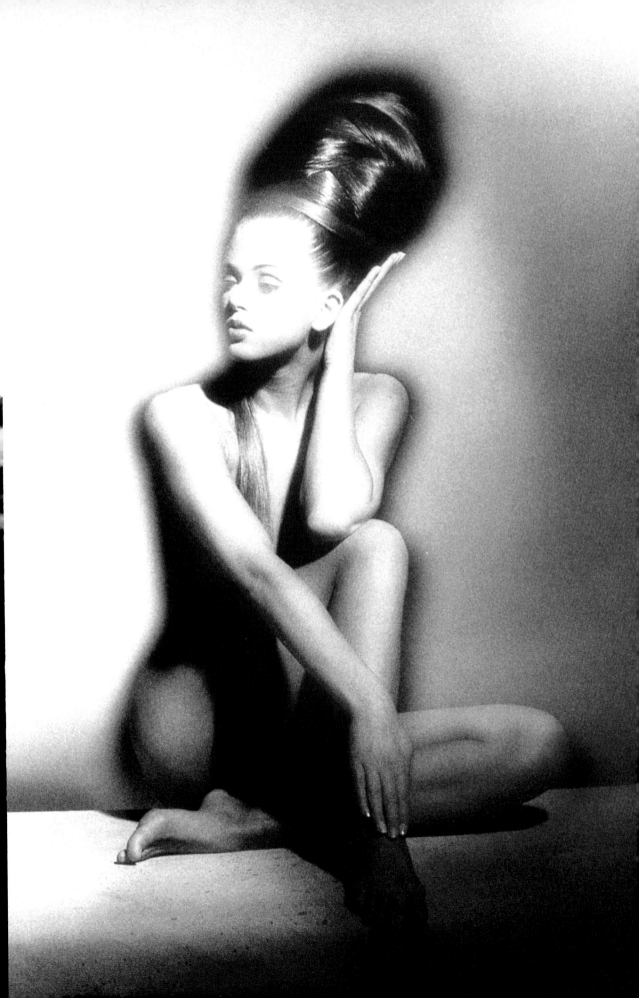

OPEN FLASH

This is a traditional technique that has been used for lighting dark interiors, usually in architectural photography. Andreas Baier decided to use the selective open flash technique simply for effect.

The resulting image was created in a darkened hall in Frankfurt airport (the office lighting shown was required for security purposes). This was how the image was made:

A quick-recharging flashgun with yellow and then blue filters was used. With the shutter speed set to B and the aperture set at f32 the photographer fired off a series of brief flashes using both filters. While the flash was recharging, the scene and the details of the Learjet remained dark. The photographer had to remember where the various parts lit by flash were. He had practiced the technique often and knew that it would succeed.

Several frames were taken and the whole session lasted for around four hours.

◀ The jet needed to be photographed in near-darkness for the effect to succeed. The session began at midnight. The photographer fired bursts of flash around and inside the jet during the long exposure.

▲ *A very long exposure was needed to allow several bursts of flash. To avoid mistakes the photographer had to remember the position of previous flash-bursts.*

PHOTOGRAPHER:
Andreas Baier

CAMERA:
Linhof 6x9 Technikardan

FILM:
Agfa Ultra

EXPOSURE:
**45 minutes (!)
at f32, B setting**

LIGHTING:
Metz 60 CT4

PURPOSE/CLIENT:
**Sony Music, for Dancepool
project 'Ultraschall'**

Hints and tips

● The basic technique is simple but the photographer needs to have a clear idea beforehand of the effect that is required. So a certain amount of pre-planning and testing is necessary.

● Such a technique demands a lot of battery power. The result opposite needed three special dryfit batteries just for one frame!

FILTERS

FILM, FILTER, AND TRACING PAPER

The darkroom provides an endless source of special effects possibilities, limited only by the photographer's imagination. Combining different materials with film and then making prints from the result is in itself a large area worth exploring by the special effects photographer. With images that can be processed in the same environment it's easy to see and assess the results of creative experiments.

Here Graham Pym has sandwiched an image with a textured filter and tracing paper. Different types were used. A fine-textured tracing paper was used for the image opposite.

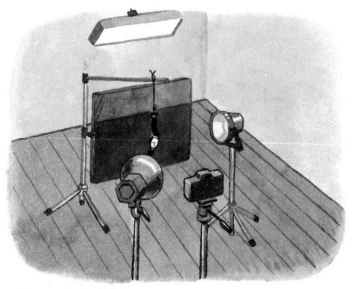

▲ *The set-up for the original image was normal. The simple composition was combined with a well-chosen background color. But a lot of the hard work and creative decisions were made at the darkroom stage.*

▶ *Some special effects succeed because they show everyday objects in a different way. This has happened here, with the pattern of the tracing paper creating a textured effect.*

PHOTOGRAPHER:
Graham Pym

CAMERA:
Canon F1

LENS:
Canon 55mm Macro

FILM:
Fujichrome 64T (tungsten)

EXPOSURE:
¼ second at f4

LIGHTING:
Angled striplight spotlight and fill-light with yellow gel

PURPOSE:
For portfolio

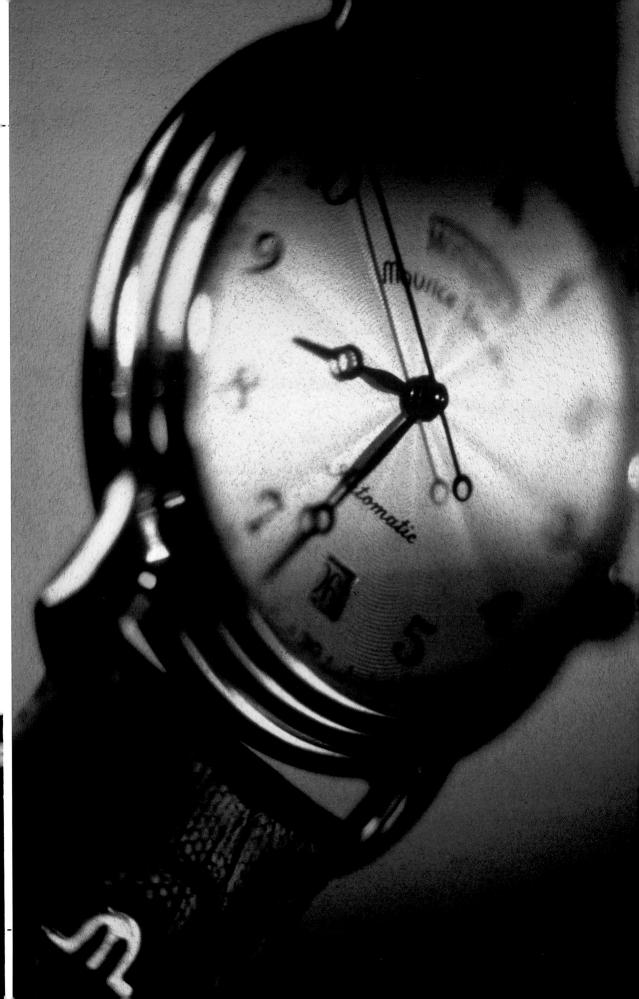

RED AND BLUE FILTERS – 1

T he photographer planned well ahead for this image.

A total of five lights were used for the original image. Two separately positioned studio flashes with dark blue filters were aimed at the floor, another studio flash with a dark red filter* was aimed at the curtain, and a light blue filter plus diffusion filter on a spotlight were aimed directly at the model's face.

Finally a softbox without a filter was also used to provide all-over illumination to the scene.

The strong colors help to frame and emphasize the dramatic features of the model.

To add a final twist the resulting image was cross-processed!

It was orignally photographed on Fujichrome 100 film then processed in color negative chemistry (C-41) at +1 stop. A C-print was then made of the resulting negative and copied on to Fujichrome duplication film. Finally an Ilfochrome print was made from this.

with barn doors plus additional panels to create a directional beam of light.

PHOTOGRAPHER:
Rob Lewine

CAMERA:
**Hasselblad CM
with 150mm lens**

FILM:
**Fujichrome 100, processed
at +1 in C-41 developer**

EXPOSURE:
**f5.6-f8 (+1 over suggested
meter reading)**

LIGHTING:
**Four Dynalite strobes:
three heads and a fourth
in a softbox, a separate
spotlight, plus filters**

PURPOSE:
For portfolio

▼ *This image is from the same session. Shot on Fujichrome Velvia it was processed in normal ie E6 chemicals.*

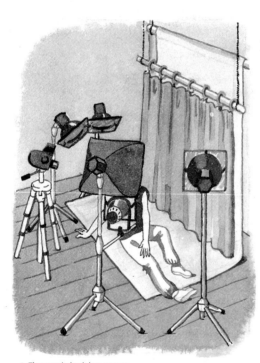

▲ *The curtain backdrop was an important part of the whole shot, and needed three sources of illumination for itself. A total of five separate sets of lighting were used for the final image.*

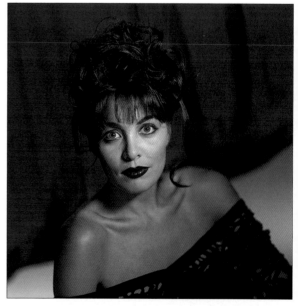

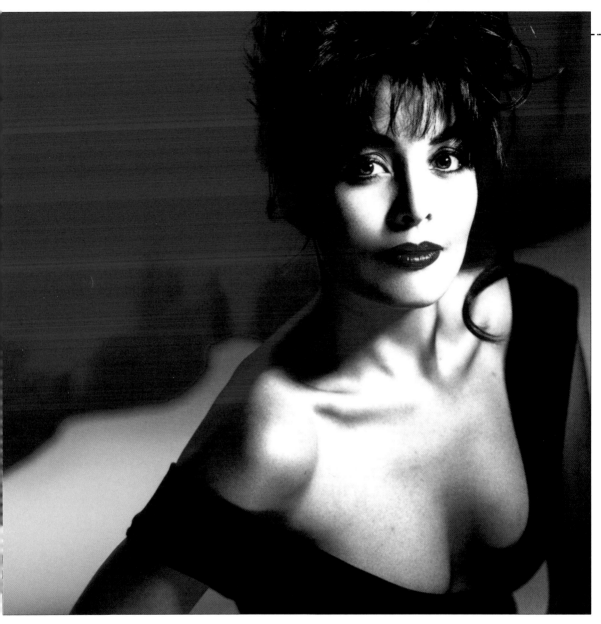

▲ *Two simple colors – red and blue – dominate this image. Add to this the excellent composition plus the model's pose and the result is a powerful photograph.*

Hints and tips

● Shoot two rolls of film of images with different colored filters and make a note of the filters used. Process one film normally, but cross-process the other film. The results will be a valuable source of reference for any future filtering and cross-processing experiments.

● Red and blue balance each other well when used in this situation. But there are other combinations that work well together too. Try green with yellow, and orange with red.

RED AND BLUE FILTERS – 2

This image uses red and blue filters in a different way.

Two light sources were used: a studio flash and a Light Brush unit. A red filter plus a patterned diffuser was placed over the main studio flash, while red and blue filters were used separately with the Light Brush to color the flowers in the vase.

A total exposure time of 10 minutes was needed to carry out the various stages required for this image.

Red is normally a dominant color, but here it simply fills in the background. Instead the flowers, with their mainly blue coloring and sharp detail, are more eye-catching.

Hints and tips

● As expected, full-strength color filters give the strongest color effects while medium and paler types give more subtle results. This needs to be noted when using strong colored filters with paler ones in the same shot.

● The effects of colored filters are strongest when the subject and background being photographed are white or pale colored.

▲ A lot of patience and a clear-headed approach were needed to get the best from the Light Brush. The photographer needs to remember which areas have been illuminated and which ones have yet to be illuminated, as the result is only seen after the film has been developed. Practice with instant film first.

▶ This is another way to use red and blue filters. Note how the vibrant red and cool blue colors have enhanced these simple objects.

PHOTOGRAPHER:
Marshal Safron

CAMERA:
5 x 4

FILM:
Fujichrome Velvia

EXPOSURE:
10 minutes at f16

LIGHTING:
Studio flash and Light Brush

PURPOSE:
Portfolio

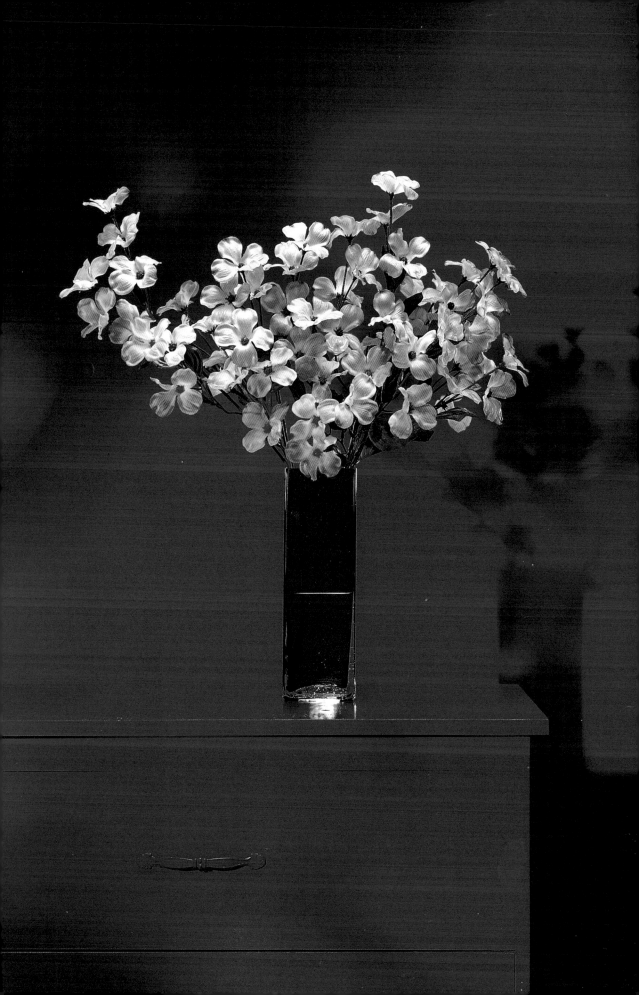

SOFT FOCUS — HOME-MADE

Home-made filters can help to make your images have a slightly different look compared to those using commercially manufactured filters. Take a photograph through a simple piece of frosted glass which has been placed just in front of a subject and the resulting image can look almost like an old painting.

A very simple procedure was used to create the image on the opposite page. The photographer first focused on the strawberries and jug then took her exposure reading off them. She then positioned the frosted glass in front of the still life and photographed through it.

The shapes have become soft and irregular colored blobs, yet it is still possible to see what the subject is that's behind the glass. Notice how one of the strawberries has a clearer shape, because it is closer to the glass.

▶ *The photographer placed a piece of mottled glass in front of a still life then shot through it. Result: a soft image yet with recognizable areas of color.*

PHOTOGRAPHER:
Sue Hiscoe

CAMERA:
Sinar 5x4 with 210mm lens

FILM:
Kodak Ektachrome 64T

EXPOSURE:
¼ second at f22

LIGHTING:
Del Fifty (1K)

PURPOSE:
Portfolio

◀ *A piece of glass was chosen which did not have a specific pattern, so as to allow the shapes behind it to be seen more clearly.*

CREATIVE FILTRATION

There are plenty of filters that can be used, say, to maintain normal colors in difficult lighting or to control contrast. But there are many that can be used purely for effect. Colored filters can be used to create strange new color effects that will never be possible in real life.

For this image the photographer has used a total of five carefully positioned filters. A low-strength fog filter was used over the camera lens to create the right amount of softness.

Then a magenta filter was placed over a spotlight that was next to the camera. This spotlight was aimed at the center of the rose (which was placed on a glass sheet).

In addition, two other filters, orange and yellow, were each placed over two spotlights (which had Fresnel lenses) at either side of the flower. Finally a red filter was used over a fourth spotlight that was aimed at the background. This created the red aura around the flower.

PHOTOGRAPHER:
Jorge Brantmayer

CAMERA:
Sinar 5x4 with 210mm lens plus fog filter

FILM:
Kodak Ektachrome 100 Plus

EXPOSURE:
**f16 for the rose,
f8 for the background**

LIGHTING:
Two Bowens studio flash units with Softboxes plus four Bowens spotlights. Magenta, red, orange and yellow filters

PURPOSE:
Falabella shops

▶*Although this image looks like the result of cross-processing or of computer imaging it was actually created using several filters.*

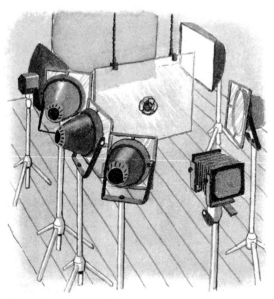

▲ *A simple image but with a complex set-up. As much illumination was needed for the background as lighting the flower from the front. The large softboxes enhanced the glowing effect.*

Hints and tips

● A lot of experimentation goes into producing an image like this. And instant film helps when checking each stage of the shot.

● It's worth making a note of positions of lights and exposure settings so that the shot can be repeated.

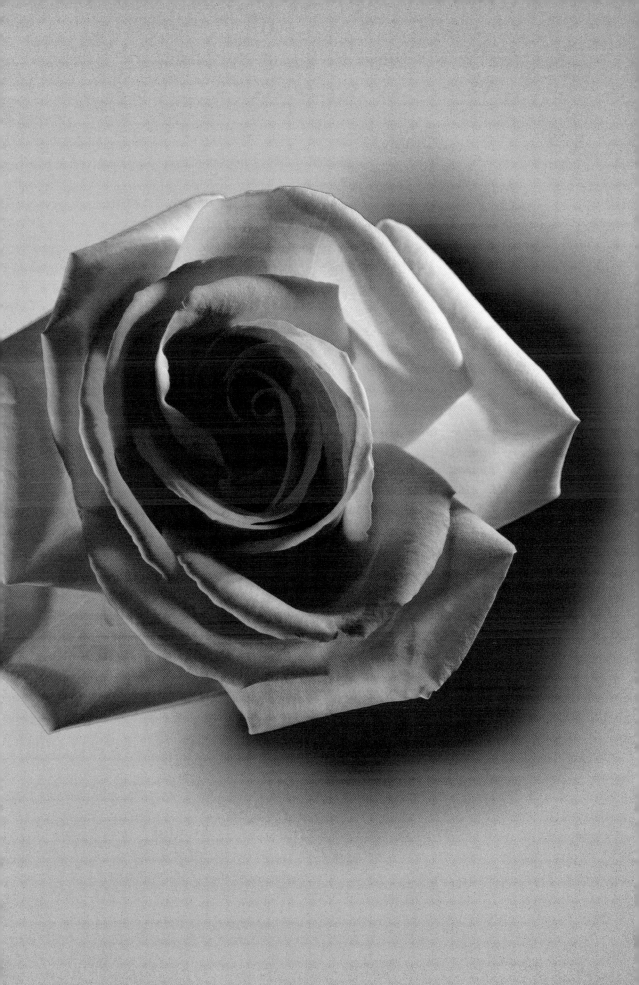

COLORED GELS AS PART OF THE IMAGE

The material used for colored gels is also available in sheets. This is to enable them to be positioned over large light-sources. These colored gel sheets themselves make interesting items for special effects use, and the photographer of this image has done just that.

The glass objects were placed on a light-table that had a black plexiglass surface. The colored gel material was positioned near the light-table to form the background. The transparent background also shows what's behind the scene, and this gives the picture a feeling of extra depth.

When there are shiny objects to photograph it's vital to use the right lighting. The soft overall lighting was produced by a medium sized softbox and two separately positioned flash heads fitted with honeycomb diffusers.

PHOTOGRAPHER:
Stefanos Samios

CAMERA:
Toyo 5x4 with Rodenstock Apo-Sironar 240mm lens

FILM:
Kodak EPP

EXPOSURE:
Not known, but was the result of several Polaroid tests

LIGHTING:
Bowens studio flash

PURPOSE/CLIENT:
For Grazia magazine

▶ *Colored gels supplied the finishing touch to this unusual arrangement of artistic glass ornaments. The colors appear within, as well as behind the glass objects.*

Hints and tips

● The soft overall lighting was a vital part of this image. The lighting needs to be carefully selected and positioned so that few shadows are produced.

● Careful positioning of the various items will help to produce a successful still-life image. Use instant film in order to assess the best arrangement of objects and the right exposure.

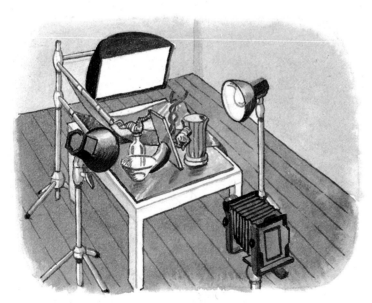

◀ *Clear glass objects usually cause problems with lighting and reflections. These items were both colored and patterned, so a normal lighting set-up was sufficient.*

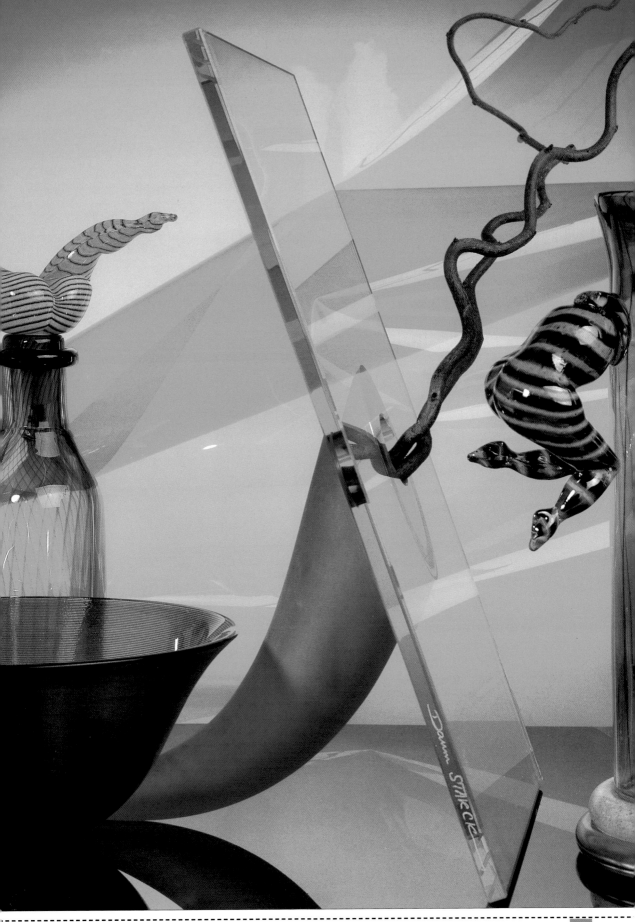

FLOATING LIGHT-BULB

The light-bulb was glued to a wooden dowel and two wires were soldered on to it to deliver the current for lighting the bulb. A small hole was drilled in the middle of a plexiglass sheet and the dowel was screwed onto it.

It was then held by two clamps on stands so that it was vertical. A spotlight with a gobo was placed behind the plexiglass sheet and a red gel was attached to it. The light-bulb was illuminated by placing a striplight at either side behind the bulb.

The exposure was in three parts:
● a curtain of black velvet was placed in front of the plexiglass and striplight and exposed.
● the two wires were connected to the light-bulb by crocodile clips and a current applied to light the bulb. All other lights were turned off and the bulb was exposed by itself.
● the black velvet was removed so that the striplight with the red gel was exposed.

PHOTOGRAPHER:
Patrick Llewelyn-Davies

CAMERA:
5x4

FILM:
Fujichrome tungsten balanced film

LIGHTING:
Two tungsten Redhead lights

PURPOSE/CLIENT:
Portfolio

▶ Long before the arrival of electronic imaging photographers have had to create unreal or impossible looking effects, often using just their imagination and some simple props, like this floating light-bulb.

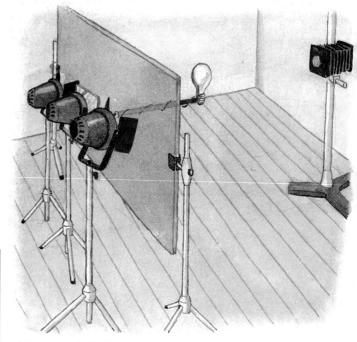

▲ The success of this effect is due to the clever concealment of the items that provided the power for the light-bulb: the two wires.

Hints and tips

● Tungsten-balanced films are intended for use with tungsten lighting. However, some filtration may be added, if required, to suit personal preferences.

● The continuous illumination from a tungsten lamp makes it easy to assess the effect of lighting on a subject.

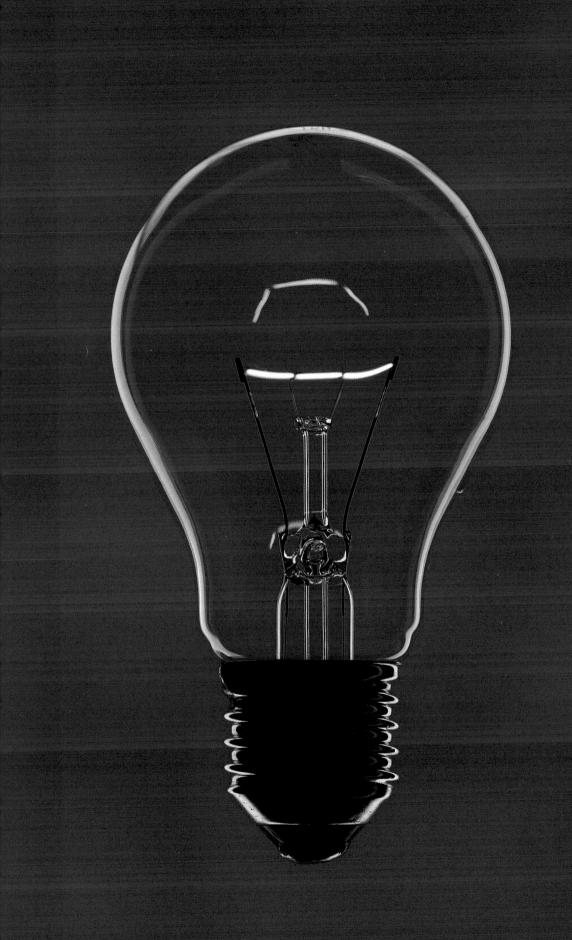

STAR FILTER

This filter creates a star effect which is most noticeable with pinpoints of light. And the fewer such highlights there are, the greater the impact.

The filter has a rotating ring so that you can adjust the angle of the star shape.

In this image the photographer has kept the composition simple and has used just one source of light – the sun – to show the star filter effect. If you look closely at the cyclist's helmet you will see smaller star shapes in the highlight reflections though these are too small to be a distraction.

The photographer used underexposure to emphasize the star effect plus a little bit of flash to illuminate the cyclist. The flash was set to a fraction of its normal power setting.

Hints and tips

● Star filters come in different kinds, depending on the number of rays or 'points' that the filter produces. The star filter used for this shot has 10-points. Others come as 4-point, 6-point etc.

● The star points are sharpest at small apertures, so take note of this when you are planning your exposures.

● A star filter produces a strong, eye-catching effect that needs to be carefully balanced with other elements in your composition. So you'll need to compose your shots with extra care when using one of these.

▲ The heavy under-exposure required to emphasize the star effect meant that the cyclist was darkened. An off-camera flashgun needed to be used to give just the right amount of additional illumination.

▶ The star effect is eye-catching and can be easily over-used, but here it is part of a well-balanced composition.

PHOTOGRAPHER:
Stig-Göran Nilsson

CAMERA:
**Hasselblad 205TCC
with 50mm Distagon**

FILM:
Kodak Panther 100

EXPOSURE:
1/500 second at f11

LIGHTING:
**Daylight, plus Metz 45
flash, with 81B filter**

SOFT FOCUS FILTER – PLUS DIFFUSION

One of the simplest and quickest ways to change an image is to use soft focus. Soft focus filters soften sharp edges and colors. They come in different strengths, from very subtle soft focus up to a very strong effect that's almost like a fog.

In this image by Sue Hiscoe a medium strength soft focus filter has been used, combined with diffusion from a light source plus lens flare. The total soft focus effect is therefore three times stronger, creating a rich glow that softens the colors of the wine-glass and bottle.

PHOTOGRAPHER:
Sue Hiscoe

CAMERA:
Sinar 5x4 with 210mm lens

FILM:
Kodak Ektachrome 64T

EXPOSURE:
¼ second at f22

FILTERS:
Soft focus filter (medium strength) over camera lens. Warm-up gel over small tungsten light

▶ *A soft focus filter makes sharp objects look less distinct. And if a bright highlight or light-source is also included in the frame it creates a diffused glowing effect.*

▲ *Using a soft focus filter in a studio gives the photographer more time to decide on the best lighting and composition. Outdoors, popular soft focus subjects are: people, plants, and landscapes.*

Hints and tips

● Try different exposure settings until you find exactly the right one. Over- and under-exposure will give different soft focus results. For example, extra exposure would cause the neck of the bottle to disappear.

● If you include a light-source or a sparkling highlight when using a soft focus filter it will have a soft halo effect around it.

● Some camera and filter manufacturers produce special soft focus filters that are also able to show some image sharpness plus a soft effect.

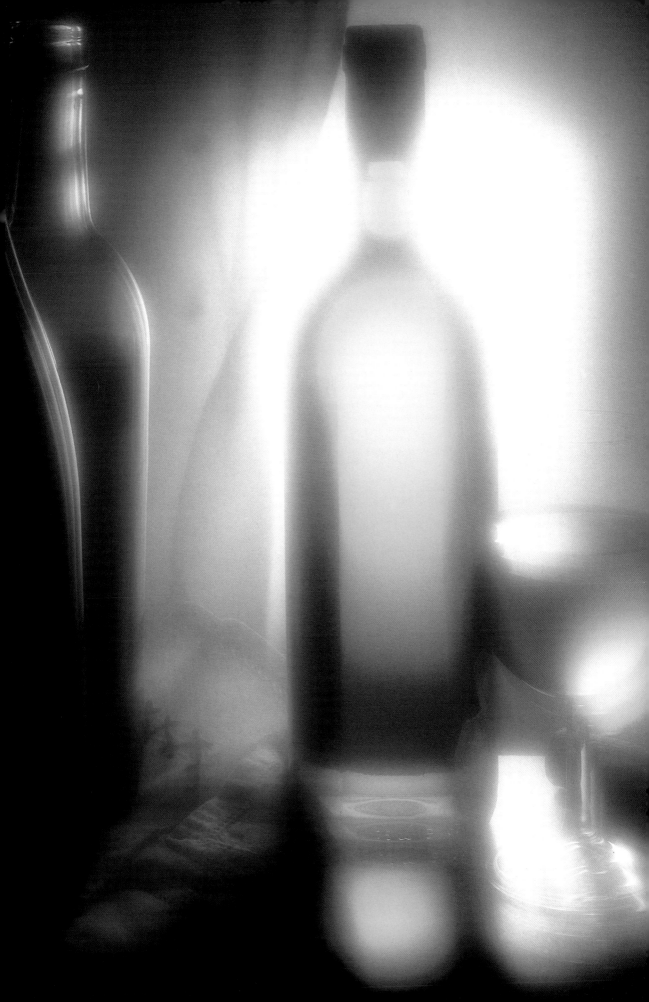

USING A FILTER AS THE BACKGROUND

By projecting a color filter on to plain white it is possible to create some striking backgrounds. Here, a rainbow filter was placed in front of a beam of light from a spotlight. The projected image of the filter was directed onto a white background, and the rainbow effect that it produced then became the background.

To add a finishing touch a sheet of chromium-plated steel was used in the foreground to create a distorted reflection of the water droplets and the rainbow pattern.

Other filters that have a strong color or pattern to them can also be used eg. plain color filters (yellow, red, orange and green) and color graduated filters. For example, a projected gray graduated filter used as a background can give the impression of being a graduated backdrop.

You can create home-made filters by using fiber-tip pens on clear plastic or acrylic sheets.

It's important to use a clear white backdrop as this will show the colors at their strongest.

PHOTOGRAPHER:
Kazuo Kawai

CAMERA:
**Sinar 5x4
with 180mm Symmar-S**

FILM:
Kodak EPY

EXPOSURE:
2 seconds at f22

PURPOSE/CLIENT:
Portfolio

▶ A sheet of chromium steel and a white background were the basis for this image. The colors came from a projected rainbow filter.

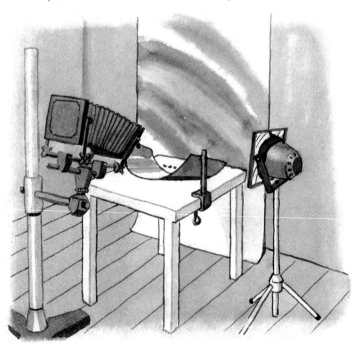

▲ With the right filter, back-projection can take the place of patterned background paper. And the area of coverage can be varied simply by moving the projector nearer or further away from the backdrop.

Hints and tips

● A range of colored filters, used with a light–source such as a spotlight or even a slide projector can sometimes be used instead of background paper.

● Take note of the color temperature of the light–source and use the appropriate corrective filtration (if using daylight balanced film). Alternatively you could use tungsten-balanced film.

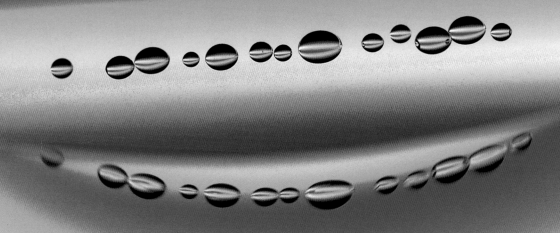

IMAGE
MANIPULATION

TONING

By toning, the photographer can create a colored image from a black and white original. The basis is a black and white print which is placed into a toning solution. The original image that had been created by conventional means (ie using silver halides) is then converted into the colors of the dye in the toning solution.

Some toners give just a slight alteration in the colors and tonal range of the print. Others produce stronger colors. There's a wide range of colors to choose from, such as sepia, blue, green, orange, red, magenta, purple, copper, yellow and gold.

The original of this image by Fina Lunes was a Polapan from which, via an inter-negative, a black and white print was made. This print was then placed in a low-strength solution of blue toner.

PHOTOGRAPHER:
Fina Lunes

CAMERA:
Nikon with 200mm lens

FILM:
Polapan 35mm

EXPOSURE:
¹⁄₁₂₅ second at f8

LIGHTING:
Not known

PURPOSE:
Tandem DDB Campmany Guash

Hints and tips

● Selenium toning enhances the tonal range of a print and makes it last for a long time.

● One type of toner requires the b&w print to be bleached first, then toned. Another type of toner requires just one stage ie the toning itself.

▶ *Toning is ideal for creating a mood. The blue tone used for this image, combined with the subject-matter and the sympathetic lighting, gives an impression of gentleness and of security.*

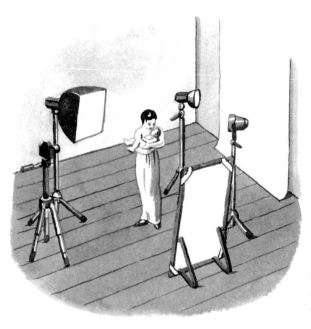

◀ *The lighting set-up can be standard, as the basic print requires normal development. Although blue toners have the effect of slightly increasing the image density, any necessary adjustment can be carried out at the printing stage.*

BURNING THE FILM

This is an unusual effect that gives a dramatic result but needs to be planned with care to safeguard a) the photographer and b) the image itself.

Mexican photographer Sergio Loman produced the image by holding a transparency over a gas flame. The flame caused the emulsion to bubble and this pattern then became a part of the image. The heat from the flame also caused the base of the film to buckle, creating the unusual shape of the image frame.

He then used the black smoke from a candle flame to selectively shade parts of the image.

Finally he made a duplicate of the finished result.

PHOTOGRAPHER:
Sergio Loman

CAMERA:
Mamiya 645 Super with 150mm lens

FILM:
Kodak Ektachrome 160 Tungsten

EXPOSURE:
¹⁄₆₀ second at f16

LIGHTING:
Two softboxes

PURPOSE:
Front cover of Rotovision source book

▶ *This image was created by holding the medium format slide directly over a gas flame! No two images burned in this way are alike – each is unique.*

▲ *When planning an image like this make sure there is plenty of free space around the subject on the frame, so as to clearly show the burning effect.*

▲ *It is safest to use tongs when burning the film. Try and move the film slowly towards the flame. Let the film remain in contact with the flame only long enough for a visible change to occur.*

Hints and tips

● The amount of bubbling depends on the distance from the flame and the length of time the film is in contact with it. Too long a time, and the film will just burn up.

● Make duplicates of your originals and only use these.

● The fumes given off when burning, for example, Kodak slide film will include: carbon dioxide (from the cellulose tri-acetate base) and sulphur dioxide and nitrogen oxide from the materials in the emulsion layer. These gases are less harmful in the small amounts likely when burning a few frames of film.* However, sensible safety procedures would be:
 a) to make sure that there is some ventilation.
 b) to make sure that there are the necessary fire precautions.

*Information courtesy of Kodak Health and Safety Department, Kodak U.K.

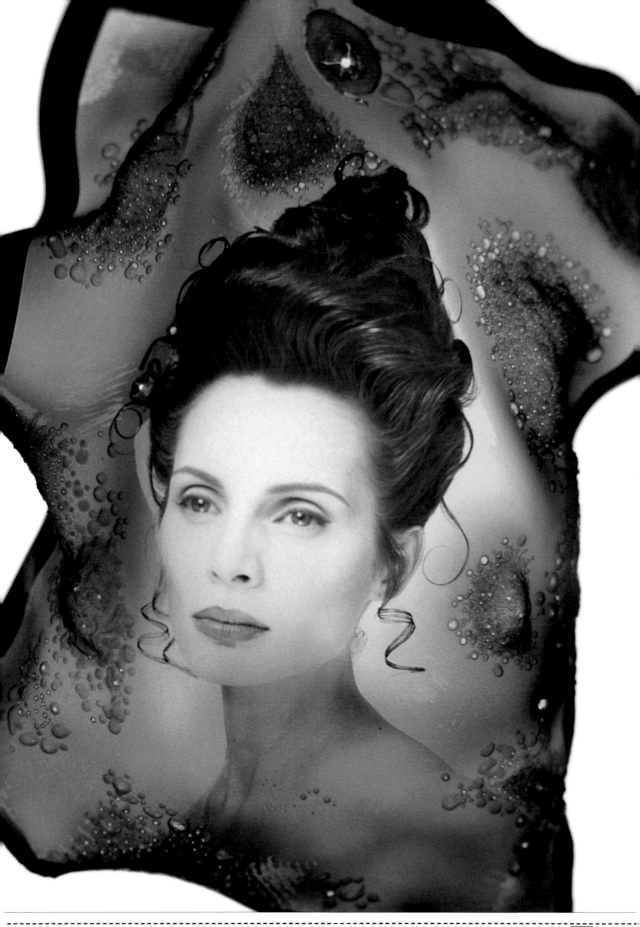

PHOTOGRAMS

t's possible to make an image without film using just an enlarger and light-sensitive material, such as film or printing paper, to create a photogram. Placing objects in direct contact with the film or paper results in strong simple shapes that have plenty of impact.

An average exposure setting first needs to be obtained by testing. This can be done by selecting an aperture and then leaving the paper exposed long enough to get a gray or black background (if working with black and white materials).

Any small objects with interesting shapes can be used such as paper clips, coins, leaves or even a hand!

Bill Westheimer used forks, knives and spoons to produce this color photogram. The originals were three black and white photograms which he then re-photographed (on color film) as multiple exposures. He dialled in different colors for each exposure.

In order to create some of the photograms a plastic spoon and fork were actually placed in the film carrier of the enlarger.

▲ *Objects that are flat or reasonably flat provide the ideal shapes that are needed for a successful photogram. Small items can be placed carefully in the enlarger's film carrier. Larger items can be positioned on the baseboard.*

▶ *A photogram is simply a silhouette of an object on a piece of film. For this image the photographer used multiple exposure and different enlargements to vary the sizes.*

PHOTOGRAPHER:
Bill Westheimer
FILM:
Fujichrome Velvia
EXPOSURE:
Not known
PURPOSE:
Portfolio

LIGHT BRUSH AND CROSS-PROCESSED SANDWICH..

Mixing two special effects techniques in one can produce an eye-catching image. The image opposite is an example of this approach, and it requires some pre-planning.

Two sheets of 5x4 film were used for this shot. The first sheet was processed normally in E6 chemistry, while the second sheet was (cross) processed in C-41 chemistry.

The image opposite was created in two stages:

1st stage: One studio flash was used for the lighting in the top half of the picture. A Hosemaster light brush was used for the items in the bottom half. These items were intentionally moved while the light brush was being applied to them.

2nd stage: a) Back in the dark-room the top half of the normal (E6) processed film was combined with the cross-processed image. **b)** Then the bottom half was combined with the normally processed film, to produce one complete image.

PHOTOGRAPHER:
Charlie Lim

CAMERA:
**Sinar P 5x4
with 210mm lens**

FILM:
Kodak Professional EPP

EXPOSURE:
Not known

LIGHTING:
One studio flash

PURPOSE/CLIENT::
Portfolio

▲ a)

Hints and tips

● Although many processing labs can do cross-processing, the rest of the above procedure requires at least some basic darkroom skills.

● The process of combination-printing can be used in other ways too. For example, try combining a color trans-parency with a color or black and white negative and print the result.

▲ b)

▶ *Two separate techniques plus some complicated dark-room skills were required to create this unusual image.*

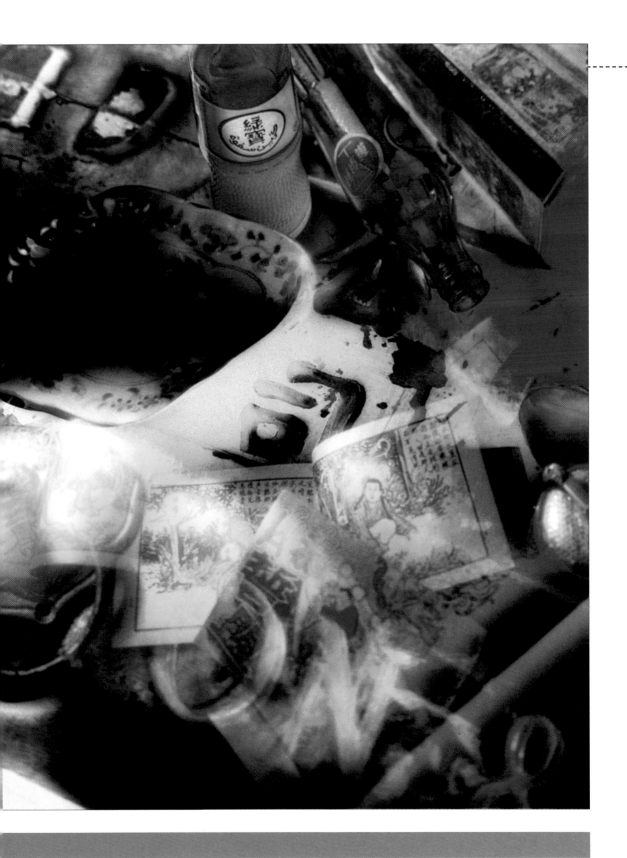

PHOTOGRAPHIC IMAGE MANIPULATION

There has always been an element of image manipulation in traditional photographic darkroom work. Darkroom equipment and techniques can help to make a good shot look even better, especially in the hands of a skilled worker.

Three separate stages were required to produce the final print of this well-composed scene, photographed on the north coast of Scotland. Two filters were used. A UV filter helped to reduce the haze in the distance and a dark red filter was used to increase image contrast.

In the darkroom the photograph was then dodged and burned to increase impact, dramatically darkening the sky and the sea.

Finally the result was printed on to color paper. The 'toned' appearance was produced simply by dialling in the required amount of color in the enlarger. The original image frame was then cropped to emphasize the rocks and sky in the final composition.

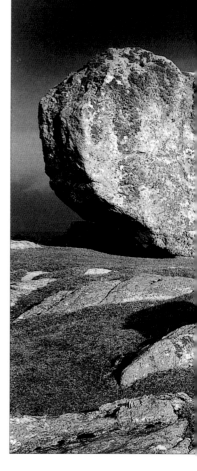

▼ *The image opposite started as a simple, black and white landscape photograph (below).*

PHOTOGRAPHER:
Lindsay Robertson

CAMERA:
Sinar P 5x4 with 90mm lens plus one UV and one dark red filter

FILM:
Ilford FP4

EXPOSURE:
2 sec at f22

PURPOSE:
For a self-promotional calendar

▲ *Careful cropping and a certain amount of darkroom work has helped to create a dramatically enhanced and moody image.*

MONTAGE

Montage is one of the oldest ways of combining two separate images. Although used by artists it works well as a photographic special effects technique.

Chris Jones tried a different type of montage by first attaching a print of an eye to a small styrofoam block. Then he placed this on to a print of a face.

The lighting was positioned so as to create an area of shadow. This emphasized the distance between the two prints, and created an effect that is almost like 3-D.

The resulting arrangement was then re-photographed as one complete image.

◀ Once he knew what he wanted from the finished montage, the photographer used a standard studio lighting set-up for the original shot.

▲ This image was created without the aid of a computer. The print of the eye was positioned over the portrait, then the set-up was re-photographed.

PHOTOGRAPHER:
Chris Jones

CAMERA:
5x4 camera

FILM:
Polaroid Type 55 (B&W prints were later re-photographed on Fujichrome)

EXPOSURE:
Not known

LIGHTING:
Soft bank light

PURPOSE:
Image (opposite) led to commissioned image (below) for Ligature

▶ The originals were in black and white. Re-photographing them on Fujichrome color slide film helped to produce the warm result.

Hints and tips

● An important part of the finished image is where the shadows fall. Short or long shadows will result depending on where the lighting is positioned.

● Another factor that will affect the finished image is the height of the block. A large block will increase separation between the top and the base images, so creating a more dramatic 3-D effect.

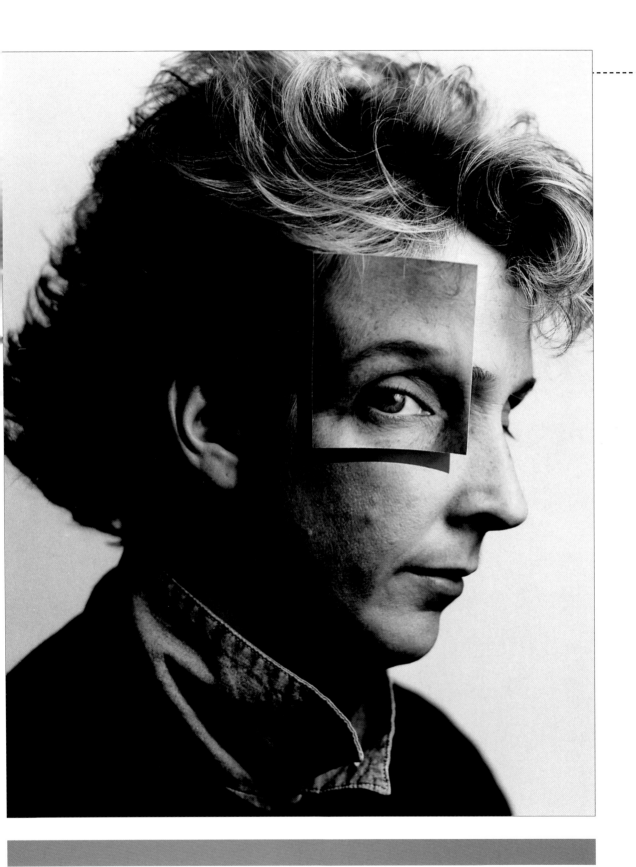

CREATING A SCENE

A client may require a situation that is difficult or impossible to do using conventional photographic means or even electronic imaging. This is where art directors, skilled background painters and set-builders can create a make-believe scene that is very close to reality.

This image first of all required a 30ft high painted backdrop including palm trees. A set-builder then created the 3-D palm trees and jetty. The jetty rested in a tank filled with water to a depth of 1ft. Then three wind-machines, a smoke machine and a snow machine were used to create the hurricane effect.

A print was made from the result, but there was more to be done. This print was placed under glass which had droplets of water sprinkled on it. The photographer then re-photographed the print, using an appropriate aperture setting to give the water droplets just the right amount of unsharpness. Finally, the print from this was placed in a reddish-brown toning solution, and the result is opposite.

PHOTOGRAPHER:
Spencer Rowell

CAMERA:
Hasselblad with 250mm lens

FILM:
Kodak Tri-X

EXPOSURE:
¼ second at f11

LIGHTING:
Three 2.5Kw HMI units

PURPOSE/CLIENT:
Glenlivet whisky (Ogilvy & Mather advertising agency)

▶ *This 'hurricane' scene was created indoors, from the specially made palm trees, to the false jetty and even the droplets on the image!*

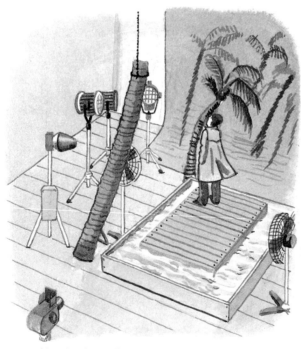

▲ *Powerful wind-machines and strong lighting plus a skilfully built set helped to create the illusion of a hurricane. The photographer framed carefully so as to avoid the machines and the lighting.*

Hints and tips

● Elaborate set-building like this can be expensive. But a client who knows what he or she wants and an inventive photographer can between them produce a memorable image.

● It's worth keeping a contact list of model-makers and set-builders, as there are still certain situations that cannot effectively be produced by other methods, such as electronic imaging.

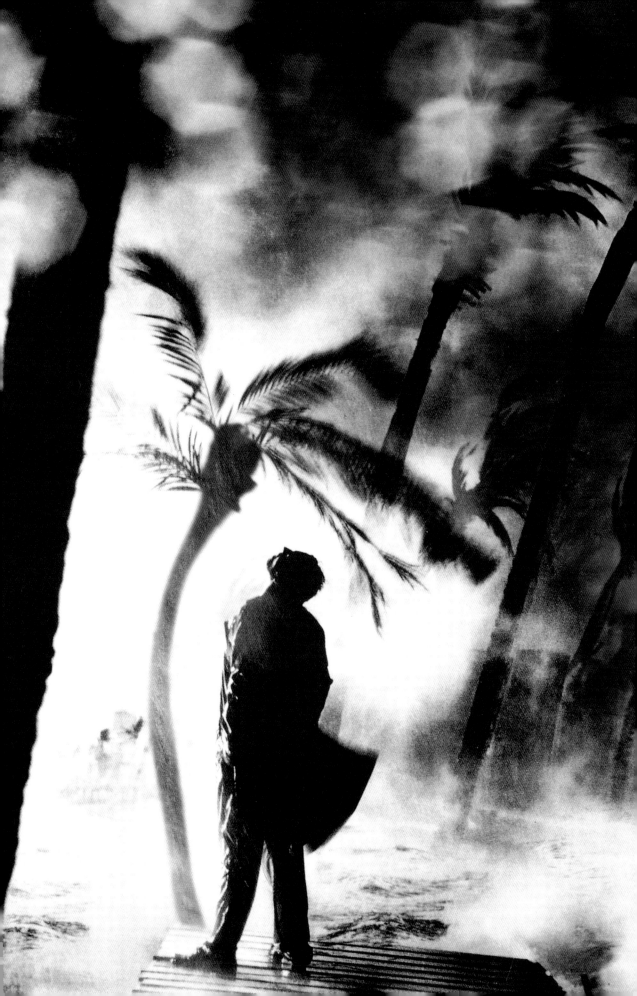

PINHOLE PHOTOGRAPHY

A pinhole camera is the basic definition of a camera that we are all familiar with: a hole in a light-tight box that contains light-sensitive material ie film. Actually taking successful photographs using a pinhole camera can be a difficult but rewarding and creative experience.

Pinhole photography gives an unusual quality to an image that is difficult to achieve by any other photographic method.

This image by Carles Mitjà was taken with a Sinar 5x4 camera. The lens was removed and in its place was a card with a tiny hole pierced at its center. Once the hole was made a series of tests was then needed to discover the optimum exposure time. With a pinhole camera the exposure time is more likely to be in full seconds or in minutes rather than fractions of a second, even in bright lighting.

The resulting image was sepia-toned to give it the appearance of an old-fashioned photograph.

Pinhole photography is a demanding technique that requires a lot of skill, practice and patience from the photographer for best results.

PHOTOGRAPHER:
Carles Mitjà

CAMERA:
Sinar 5x4 plus card with pinhole

FILM:
Kodak Tri-X at ISO 320 developed in Kodak HC-110 B

OTHER DETAILS:
Printed on Oriental Seagull paper using a cold light enlarger then sepia toned

PURPOSE:
For advertising agency

▲ *Any removable lens camera can be used for pinhole photography. The pinhole 'lens' needs secure positioning.*

▲ *A camera with automatic exposure can be useful when calculating the exposure needed for pinhole photographs.*

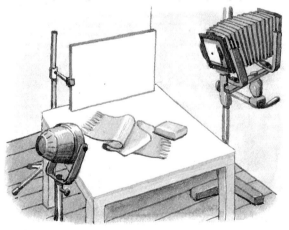

◄ *For this picture the illumination was provided by tungsten lighting. Such a constant light-source is ideal, as exposures may last for several minutes.*

▲ Pinhole photography pro-
duces results that give soft
edges to objects. The photog-
rapher sepia-toned the image
in order to create an old-fash-
ioned look. Pinhole Photography
requires planning and patience
for success.

Hints and tips

● The 'focal length' is the distance
from film to pinhole, measured in
millimeters.

● A pinhole on thin material, ie metal
foil produces a perfect circular hole. Base
the exposures on an f150 aperture –
then bracket extensively!

HAND-COLORING

Hand-coloring (also known as hand-tinting) is a technique that gives direct control over colors in a finished image. It produces colored images that would be difficult or impossible to create using conventional photography, images that provide creative satisfaction and also have commercial potential.

The base image can be a black and white print (on matt paper) that has a good range of tones and is slightly over-exposed.

The colors can be applied thinly, producing subtle hues. Or they can be applied in thicker layers to produce strong colors. Flowers, for instance,

generally benefit from subtle coloring while man-made objects such as architecture or street signs may benefit from stronger colors. As with any creative experiment, it's best to try different approaches with your chosen subject to see which one is the most effective.

The image opposite was originally photographed on Konica 750 Infrared black and white film. Contrary to standard practice with black and white infrared film, a red filter was not used.

The image was printed on Ilford Multigrade fiber-based paper with a matt finish. It was then colored using Prismacolor pencils.

PHOTOGRAPHER:
Regis Lefebure

CAMERA:
Canon EOS A2E with 35-300m zoom

FILM:
Konica Infrared black and white

EXPOSURE:
Not recorded

LIGHTING:
Late afternoon on Maui, Hawaii

PURPOSE:
Illustration for United Airlines' Hemispheres magazine

▶ *Hand-coloring produces a distinctive result that stands apart from a conventional photographic image.*

▲ *An art background is not really necessary to produce good hand-colored images, but some skill in using brushes or pencils and a knowledge of how colors work together will be useful.*

Hints and tips

● Make more than one version of the base print, in case of accidents. These extra prints can also be used for any alternative coloring methods.

● Just some of the materials that can be used are: photographic dyes, food coloring, oil paints, crayons, fiber-tip pens, artist's inks.

● To start with, use weaker versions of the chosen colors as a starting point then gradually build up the layers to the required color densities.

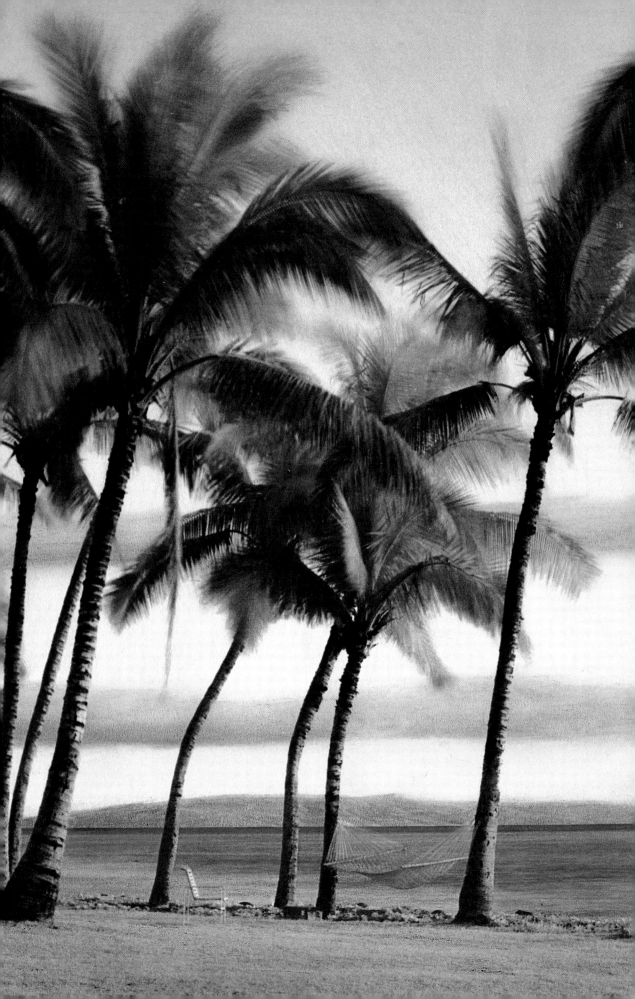

Hand-retouching

Hand-retouching is a technique that has long been used for image enhancement and image alteration. The depth of fine detail and tone that is possible with it is superior to that which can be achieved with most forms of electronic image manipulation.

There is a range of special coloring materials that can be used for hand-retouching in the form of inks, paints and even coloring pencils. It's also possible to use ordinary coloring materials such as fiber-tip pens and artists' paints, though the color effects and their durability may vary.

Ivano Confalone hand-retouched the areas around the outline of the figure, and then copied the result on to Agfa Optima 400. The grainy result produced by this film has added to the overall effect.

The photographer was influenced by the chalk and charcoal sketches of Michelangelo and he tried to achieve the same results using photography. The technique took a long time to develop. One of the most difficult procedures was trying to get the subtlety of color just right.

PHOTOGRAPHER:
Ivano Confalone

CAMERA:
Mamiya Press Universal with 90mm lens

FILM:
NPL 160

EXPOSURE:
1 second at f8

LIGHTING:
One tungsten light positioned above the model, to the right. White background.

PURPOSE/CLIENT:
Portfolio

▶ *The photographer tried to create an effect similar to Renaissance sketch by using an individually perfected hand retouching technique.*

▲ *With this kind of technique a conventionally lit studio shot is only the starting-point. A moderately high-key lighting set-up and plenty of space around the main subject was the basis for the image opposite.*

Hints and tips

● The original print must be on a non-glossy or low-gloss paper surface eg. there are special photographic papers that have a texture that is similar to water-color paper.

● An overexposed original image provides a suitable basis for filling in areas of color by hand.

GUM BICHROMATE

Gum bichromate is an alternative printing technique that produces an effect that looks almost like a painting. The gum bichromate is made from potassium dichromate and gum arabic. It requires an absorbent surface, such as water-color paper, for good results. The image opposite was created in the following way:

Using the original 35mm as a basis, a 12x16in. inter-positive was first made, and then an inter-negative was made from this, on a special graphic arts film.

The water-color paper was then coated first with yellow for the high-light areas. It was exposed to UV light from a sunbed (although normal sunlight can also be used) for 20 minutes.

After this it was washed and dried, ready for the second (venetian red) coating of gum bichromate followed by a shorter exposure under the UV lamps. This coating was for the mid-tone areas of the image. After the image was again washed and dried there followed a third coating, of blue-black, for the shadow areas.

Finally, a cyanotype process (which produces blue) was used for the fourth coat. It was brushed vertically and horizontally to produce the final result.

Hints and tips

● A contact procedure is required to transfer the image onto the paper, so the resulting image size depends on the size of the negative. Smaller formats than the one mentioned above can also be used eg. 10x8 or 5x4in.

● It takes time to prepare the gum bichromate and to produce the final gum bichromate image, so a certain amount of pre-planning is required.

▶ This timeless image was created using gum bichromate as the basis. The textured effect was produced by vertical and horizontal brushing of the picture surface.

PHOTOGRAPHER:
Charlie Mattina

CAMERA:
Canon T70 with 50m lens

FILM:
Ilford FP4 and Cronalar Graphic Arts film

EXPOSURE:
$1/125$ second at f16

LIGHTING:
Sunny morning, between 8 and 9 a.m.

PURPOSE/CLIENT:
Portfolio

◀ The b&w film was able to respond to changes in exposure and development. It began as a medium contrast image.

ELECTRONIC IMAGE MANIPULATION – 1

Electronic imaging is becoming an additional photographic tool, used to create special effects that cannot easily be created any other way.

There are many darkroom tricks that can be done by using a computer, and without using chemicals or working in the dark.

Moving objects in an image is easy when using a computer.

Hong Kong based photographer Kevin Orpin created this image by combining parts of three different transparencies. The fourth and final transparency (opposite page) was a brand-new image.

PHOTOGRAPHER:
Kevin Orpin

CAMERA:
Fuji GX680

FILM:
Fujichrome 100D

EXPOSURE:
1/30 second at f8

LIGHTING:
Two enclosed arc AC discharge lamps – 1.4 Kw and 4Kw (HMI) flicker free top lighting only

PURPOSE:
for The Regent Hong Kong

How it was done:

◀ *Pic 1: The girl in a mermaid costume was placed in a pool and photographed through a glass window. The silver cloche and tray she was holding were separated by a piece of plastic so as to create a space to insert the fish.*

▶ *This image succeeds because the different elements, when brought together, produce a realistic looking result.*

◀ ▼ *Pics 2 & 3: The images of the coral on the sea-bed and the fish were taken from two other transparencies.*
Electronic imaging was then used to bring the three separate transparencies together to create this photograph, which was used for the opening of a seafood restaurant.

Hints and tips

● For an image like this each stage needs to be planned carefully.

● It's worth having access to a slide library, or maintaining a wide selection of your own work as a source of material for electronic imaging.

● Even a basic familiarity with electronic imaging will prove a valuable future asset for photographers.

ELECTRONIC IMAGE MANIPULATION – 2

E lectronic image manipulation can be used for bringing together different elements to produce a new image that looks almost real. It can also be used for more obvious special effects so as to create results that look impossible to re-create in real life. This is why it can be such an exciting device in the hands of an inventive special effects photographer.

Patrick Barta altered his straight image of the TransAmerica building in San Francisco to give it a wavy look. This rippled building could almost have been created by a modern architect!

Note how the surrounding buildings are unchanged, giving the whole scene a look of normality.

Hints and tips

● One of the greatest benefits of electronic image manipulation is that it encourages experimentation. Results can be bizarre and unreal. Or, to create a different kind of impact, they can be subtle and closer to reality, as in the image on the opposite page.

● Most currently available computer workstations have the capability, when used with the appropriate software and memory configurations, for electronic image manipulation.

▶ The photographer used part of a nearby building to frame the original image.

◀ The original image, also by Patrick Barta, was scanned onto a Professional Photo CD. Adobe Photoshop® was used to create the wave effect (right). The final image was output as a 5x4in transparency.

PHOTOGRAPHER:
Patrick Barta

CAMERA:
5x4 with 135mm lens

FILM:
Kodak Ektachrome

EXPOSURE:
¼ second at f22

LIGHTING:
Evening

PURPOSE:
Original 'straight' shot was photographed for a client then later manipulated

ELECTRONIC IMAGE MANIPULATION – 3

The previous pages have shown two uses for electronic image manipulation: to achieve difficult photographic set-ups that look natural, and to distort one element in a scene.

A third way to use image manipulation is to alter the colors of a scene. The tools of electronic imaging make this task easy but an important skill is to know how far to go. It's an easy temptation to over-use the massive range of visual effects offered by electronic imaging.

Pete Saloutos kept things simple in the Chrysler Building shot. In this solarized image the strange colors of the sky complement those of the building.

Yet the shapes of the clouds and the building themselves have not been changed. So the scene remains recognizable, in spite of the unreal colors.

How the manipulation was created: the 35mm slide was first scanned to Photo CD. It was then moved as an 18Mb image file on to an Apple Macintosh Quadra 950 (640Mb/1.2G). Adobe Photoshop 3.0 was used to increase the color levels and then to solarize the image.

The color levels were then inverted, equalized and adjusted to the photographer's preference. The final image was transferred to a sheet of 5x4 transparency film.

Hints and tips

● For photographers who don't have a digital camera/scanner: Photo CD is currently the most convenient high-quality method of transferring photographic originals, slides, negatives or prints, onto a computer.

● A computer that is to be used for electronic image manipulation needs a lot of RAM (memory) to produce large, high-resolution images.

▶ *Computer-assisted special effects can be used to create results that were previously only available using complicated darkroom techniques. This solarized image of the Chrysler building is a good example.*

▲ *Most image manipulations start with a photographic original. The photograph (print, negative or slide) is then scanned onto the computer via a Photo CD, scanning device or digital camera. Here the image is manipulated and the result can be placed on a cartridge for distribution. Alternatively, by using a special device it can even be turned into a 35mm, medium format or large format digital transparency.*

PHOTOGRAPHER:
Pete Saloutos

CAMERA:
**Nikon F4
with telephoto lens**

FILM:
Fujichrome Velvia

EXPOSURE:
1/125 second at f8–11

LIGHTING:
p.m.

PURPOSE:
Portfolio

MULTIPLE IMAGE MANIPULATION

Some images just cannot be created using photographs alone. Several photographs were brought together to create the image opposite. Some were taken in a studio, others were from picture libraries on CD. Some needed to be altered, while a lot of drawing in and painting was also done to fulfil the client's requirements. The client wanted to show a sense of balance, progress and the future. Here's how the image was achieved:

A photograph of ball-bearings was originally used as the basis. But they weren't shiny enough, so the chrome balls were created in a software package called Strata Studio Pro. The chain, rope and pieces of watch cogs were photographed in the studio and then adjusted in Photoshop.

Then, using Live Picture software, photos of a circuit board, clouds, an old map and a cityscape were distorted and mixed with the chrome balls. Also included were some drawn images eg. the rocket, old machinery, and Leonardo Da Vinci's Vitruvian man was used as the basis for the human figure.

The final painting and adjustments were in Photoshop. Unsharp masking* was used as required.

*Unsharp masking means making the edges of pixels sharper, to increase the overall effect of sharpness.

PHOTOGRAPHER:
Steve Climpson

ILLUSTRATOR:
Sue Climpson

CAMERA:
SInar P 5x4 camera with 240mm lens

FILM:
Kodak Ektachrome 64

EXPOSURE:
f45 with flash

LIGHTING:
One softbox

PURPOSE/CLIENT:
Martek

▶ *A complex result like this – made up from photographic and painted images – can be achieved with the right software skills.*

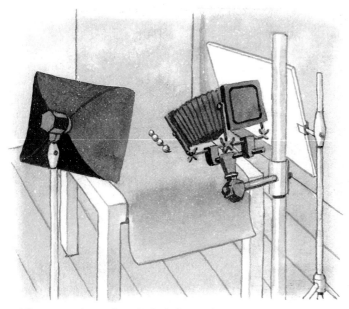

▲ *When you are photographing objects for use in image manipulation it is best to use normal studio lighting and a clear, simple composition.*

This kind of approach makes the various objects easy to 'cut around' when they are being manipulated later on the computer screen.

Hints and tips

● The right combinations of brush and filters can produce beautiful results. Make and save brush designs and useful palettes once you've finished with them.

● Don't use pieces of other people's work – whether photographs or illustrations – in your images, unless they're copyright-free.

MANIPULATING SHAPES

The photographer, client and the computer artist selected an appropriate skyline, making sure that the buildings that were lined up in the scene matched each other in perspective, lighting and tone. Many of these aspects can of course be corrected in the computer but an original photograph that has a lot of the required elements means less work is required on the computer.

A body builder was then photographed, lit by a large softbox that was positioned at the same angle as the sun had been for the skyline image. A flash used with the softbox produced highlights that helped the computer artist when positioning the body over the building.

Several instant film test prints were taken until the right body position was found. The film was then processed. The resulting image of the body was combined with the skyline and made into a print. This composite print was then used as a guide. The computer artist referred to it in order to create the finished image.

▲ This conventional landscape image was combined with a photograph of a body-builder, and then manipulated on a computer to produce the image on the opposite page.

▶ The creative freedom of computer manipulation is illustrated in this composite image, which conveys strength, solidity – and humor.

PHOTOGRAPHER:
Joe Aker

CAMERA:
Linhof Technikardan 5x4

FILM:
Kodak Ektachrome 100 Plus

LIGHTING:
Large softbox and flash

PURPOSE:
For a trucking company. Agency – Grey Advertising, San Francisco

PHOTOGRAPH OR PAINTING?

Many software packages have settings that enable the user to imitate the materials used by painters such as oil, water-color, pastel etc. So what was originally a photograph (and most electronically manipulated images begin this way) often ends up as non-photographic in appearance.

Steve and Sue Climpson, the photographer and artist who between them created the image opposite, decided to show parts of a conventional photograph and an oil painting effect in one image. How it was done:

First of all, a conventional still life of bottle, wine glass and fruit bowl was photographed in the studio. The resulting photograph was then scanned in to a computer and then selectively sized and positioned using Live Picture (a high-end image manipulation software program).

The paint effects were created in two other software programs, Adobe Photoshop and Fractal Design Painter, using a brush design that had been specially created to produce an oil-paint effect.

An add-on program to Photoshop, called KPT Convolver, was used to create a 3D effect with the paint to make it appear more lifelike.

▲ This unusual combination of photograph and oil painting effect was created using four software programs, and was the successful completion of a client's idea.

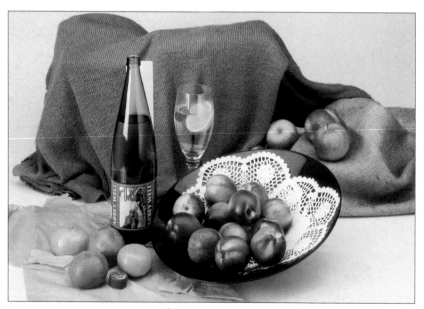

▲ The basic photograph was shot with the knowledge that it would later be manipulated. So the lighting set-up that was chosen was clear and simple, with the two main elements – the bottle and glass – being easy to paint around. The table was painted in on computer, as was some of the fruit.

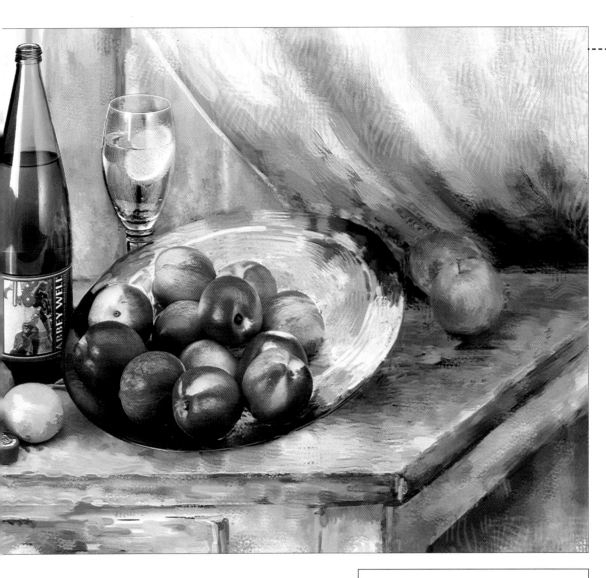

PHOTOGRAPHER:
Steve Climpson

ILLUSTRATOR:
Sue Climpson

CAMERA:
**Sinar P 5x4 camera
with 240mm lens**

FILM:
Kodak Ektachrome 64

EXPOSURE:
f32 with flash

LIGHTING:
Two softboxes

PURPOSE/CLIENT:
Automobile Association

Hints and tips

● Get the best quality scan that you can afford, even if at a later stage you may have to 'paint' over or wipe out part of it.

● Spend some time playing with filters* in combination with each other and with the other effects. Then make a copy of the good ones for later use.

● Be on the look-out for useful objects or backgrounds that can be scanned and kept for later use, for example, seasonal objects such as autumn leaves.

*In a software package a 'filter' is an effect.

DIRECTORY OF PHOTOGRAPHERS

Joe Aker is a Houston-based photographer specializing in architectural photography. His clients include many of the major architectural firms in the United States and his work has appeared in all of the major architectural magazines. He holds a degree from the Rochester Institute of Technology in professional photography. A major speciality of his firm is the photocomposites of an architectural model and building site to show what the building will look like after it is finished. His work takes him worldwide on assignment.

Tel: 713 862 6343 Fax: 713 862 3771

Daniel Allan has been an advertising photographer for eight years, specializing in location, interiors, people and cars.

He has worked for various agencies and design groups on accounts as diverse as Renault, The Royal Mail, BT and Shell.

He has worked in the United States, Australia, Bermuda and South Africa.

Tel: 0171 582 3230 Fax: 0171 820 0812

Andreas Baier is a photographer who has a background in fine art. His images have been sold through Sotheby's and been exhibited alongside work by Andy Warhol and John Baldesare in New York. Although his refreshingly different style is tinged with humor his work, especially the light-painting images, is based on solid and painstaking photographic techniques. His current areas of specialization are still life and portraits.

Tel: 0044 181 607 9271

Tom Baker studied photography at Medway College of Design, then assisted various photographers in London in the 1970s. This work involved still life, fashion and location in the UK and abroad.

Since 1978 he has been based in Scotland. His areas of specialization are still life, location and aerial photography. A large part of his work involves photographing estates as well as the exteriors and interiors of large houses.

Tel: 0463 220703 Mobile: 0831 091766

While Seattle-based photographer **Patrick Barta** has been shooting professionally for over fifteen years, his entrance into the digital world of photographic retouching and manipulation began only two years ago. A generalist at heart, the majority of Patrick's work consists of assignments for advertising, corporate and architectural clients.

Tel: 206 343 7644 Fax: 206 343 1411

Bien S. Bautista heads two photographic businesses and also supplies images to a picture agency. His field of work is in photography as well as digital imaging, and he works with advertising, corporate and editorial clients. Advertising clients include J. Walter Thompson, Saatchi & Saatchi and Philippine Airlines.

He has on-site film processing services and facilities for computer manipulation.

Tel: 817 3759/817 6848/816 4874
Fax: 812 3324

Richard Berenholtz began his career as a professional photographer in 1984 after spending 10 years as an architectural designer for prestigious international architects I. M. Pei & Partners.

He specializes in architectural, location, landscape and panoramic photography. His client list includes companies such as IBM, AT&T, Citibank, Sheraton, Marriott, Trump & the U.S. Postal Service.

He has three books to his credit: Manhattan Architecture, Inside New York and Panoramic New York.

Tel: 212 222 1302

Patrick Blake has been working as a photographer 'selling things', as he puts it, since he left college. He freely admits to having been lucky to get some plum assisting jobs early in his career, such as working for George Nicholls and freelancing with some of the top names of that era.

He worked in Covent Garden through the 70s when the old banana warehouses were converted to photographers' co-operatives before starting his own studio. These influences have given him insight into techniques which can be used, sometimes in an unusual way, to achieve different photographic effects.

Tel: 0171 286 5148 Fax: 0171 266 2335

Jorge Brantmayer is a 41-year old professional photographer based in Santiago, Chile. He is experienced in various areas of commercial imaging such as reportage, fashion, travel, art and especially still life including food photography.

He is a member of the Asociación de Fotógrafos Publicitarios Chilenos (Fotop). His clients include Northcote, BBDO, McCann Erickson and Ogilvy & Mather. He has carried out editorial assignments and has also exhibited his work.

Tel: 2235 4416/2235 0355 Fax: 2235 4416

Andrew Cameron has developed a broad client base ranging through advertising, design and editorial fields. His use of vibrant backgrounds and quality lighting produces a style which remains distinctive yet still comprehensively geared to appeal to all markets.

He has produced stylish fashion brochures for various manufacturers and fashion editorial for Esquire, FHM and Men's Health.

His homewares/products portfolio includes commissioned work for Marks & Spencer, Selfridges and John Lewis.

Through design groups he has produced many brochures for clients such as Abbey National, Centec, The Mocatta Group and United Newspapers. He has also produced numerous CD covers for international record labels including Parlophone, Erato, Stax and Virgin.

Tel/Fax: 0171 608 0606

Müfit Çirpanli started his career in Cenajans-Grey Advertising as an assistant photographer in 1985. After five years as a photographer in this well-known company he set up his own studio. He specializes in creative still life for commercials and currently works for a number of leading agencies in Turkey, producing images for leading brands.

Tel: 212 233 0834 Fax: 212 231 2534

Steve and Sue Climpson formed a partnership in 1989 to work on Apple Macintosh-based projects.

Their chosen area of work covers pure photography, Mac-based illustration, photography with illustration and manipulations, design work (including photography and illustration), and graphics.

They are based in Hampshire and have two studios. Their son is a photographer who works with them.

Tel: 44 1256 895600 Fax: 44 1256 895700
Email: 100114.2600@compuserve.com

Ivano Confalone is continually exploring fresh creative possibilities. He has evolved a technique that photographically achieves an effect that is similar to the chalk and charcoal sketches of Michelangelo. It is a technique that took a long time to perfect, especially in the area of color subtlety.
He has won design and publishing commissions and hopes to specialize in the field of advertising photography.

Tel: 44 0973 388452

Peppe Ericsson has worked as a professional photographer for 16 years. He's the third generation in his family to take up the profession. His father started a portrait studio and Peppe has a commercial studio in the same building as his grandfather had a portrait studio. He assisted his father for ten years before branching out on his own. He has also worked for a while in St. Petersburg, Florida and found it influential and creative.

Half his work is studio while the other half is location. His main areas of work are in product and people photography.

Tel: 8 716 5050 Fax: 8 718 45 44

Michèle Francken is based in Belgium in the family photographic business N. V. Francken C.P.M. It has its own laboratory and specializes in fashion catalogs as well as fabrics.

As well as commercial photography she also experiments with personal work and has had several exhibitions.

Tel: 9 225 43 08 Fax: 9 224 21 32

Mark Hilden, New York City beauty photographer, specializes in high-impact imaging for fashion, beauty and fine art. He says:

'My duty as an artist is to show a vision of the future that is positive, bright and full of color. If life imitates art then certainly the photographer, painter, sculptor and writer are some of the most important people in the world.'

Tel: 212 768 3204

Sue Hiscoe has, since leaving the Graham Poulter group in 1982, established a Leeds-based partnership. Her creative eye in the field of food expertise has been in demand from design consultants, advertising agencies and general clients.

Her portfolio consists of 70% food photography and 30% creative/special effects.

Tel: 0113 250 0007 Fax: 0113 250 0024

Chris Jones has been in business since 1976, and has subsequently traveled internationally for dozens of Fortune 500 companies. During the 1980s he produced photographs exclusively for use in corporate annual reports, specializing in banking, oil and gas, and biotechnology industries.

He moved from New York City to the Catskill Mountains in 1991 and built a state of the art studio in an abandoned dairy barn. He now shoots portraits and conceptual illustrations for magazines and books. His most recent work includes illustrations for a CD issued on Polygram Records.

Tel: 607 746 3063

Kazuo Kawai graduated from the Faculty of Photography at Nichidai School of Art. After working for the advertising department of Sharp and the photographic department of the agency Hakuhodo he founded Kawai Studios in 1980.

In 1988 he arranged the Exhibition of Advertising Photography which represented the 100 most famous photographers in the world. His work is displayed in the George Eastman House International Museum of Photography and he has received many prizes, including a prize for Industrial Advertising Photography.

His main area of specialization is still life and his ambition is to develop this further.

Tel: 03 3777 7273

Youngsoo Kim learned photo-illustration at the Brooks Institute in the U.S.A. and graduated from Ohio University with an M.A. in photo-illustration. He worked as an assistant to Louis Jurado in New York and from 1984-86 became chief photographer at Sam Hee Communications Inc, Seoul.

In 1987 he established an advertising photography studio, Studio 416, in Seoul.

Tel: 02 236 2400 Fax: 02 236 4160

Ben Lagunas studied photography in the U.S.A. and is based in Mexico. He has worked as a master fashion photography instructor for Kodak. He now works around the world for several advertising agencies, general clients and magazines such as Vogue and Swimwear Illustrated.

Together with his wife Alex he runs Blak Productions, a company that provides photography and full production services including model and talent casting.

Tel/fax: 72 17 06 57
Mobile: 905 507 4590

Regis Lefebure is a three-times winner of advertising awards for images of the Transamerica Pyramid. He has also won editorial awards for hand-colored photos of Hawaii and five-and-dime stores.

His hand-colored prints are held in fine art collections across the U.S.A. and he has two books in progress. He is currently seeking representation in Europe.

Tel: 301 270 8325

Rob Lewine, an ex-musician, is a Los Angeles based photographer whose clients include magazines, design firms, advertising agencies, corporations and the entertainment industry. He also produces stock photography for the Stock Market photo agency and is preparing to direct, in autumn 1997, his first feature film.

Tel: 001 213 654 0830
Fax: 001 213 654 9625

Simon Lewis originally worked as a graphic designer but an interest in photography led him to take it up as a full-time profession. He has won a Sun Life Portrait Award.

His areas of specialization are black and white portraiture but transformed into color via darkroom processes that include toning and gum bichromate.

He produces work for company reports and design groups and among his client list is The Standard Chartered Bank and London Transport.

Tel: 0171 377 0773 Mobile: 0956 904759

Charlie Lim studied graphic design and commercial photography at Baharuddin and started his own company 15 years ago. He specializes in light-painting techniques that he studied under Aaron Jones in the U.S.A. He has photographed fashion, food and places. His work has taken him around the world.

His clients include major advertising agencies, design houses and publishing houses.

Tel: 305 220 1651 Fax: 305 220 9181

Patrick Llewelyn-Davies started his career at Salisbury College of Art where he completed a three-year course in photography. He then moved to London and spent a year working as a full-time assistant to a photographer. To gain more varied experience he spent two years freelance assisting before setting up on his own. He is now mainly studio-based and enjoys shooting jobs which provide a challenge as well as the more straightforward ones.

Tel: 0171 253 2838 Fax: 0171 250 3375

Sergio Loman is a Mexican photographer who presently enjoys a well-recognized status both in his own country and abroad. His images appear in various specialist photographic magazines as well as in publicity campaigns. His work is on the cover of Art Director's Index to Photographers No. 20.

This year will see the publication of his first book containing his images and writing.

Tel/Fax: 575 48 61

Fina Lunes was educated at the Elisava School in Barcelona. She began her career in 1978, specializing in portrait photography. Since 1984 she has worked in fashion photography, in which she has been noted for her view of lingerie and corsetry.

The range of her work currently includes fashion, publicity, still life, portrait and author photographs.

She also conducts seminars in fashion and portraiture at the Catalunya Institute for Photographic Studies.

Tel: 3 218 7055 Fax: 3 416 0358

ondon-based **Charlie Mattina** has been reelancing for five years. He divides half his ime between photography (mainly corporate work) and printing. In the past two years, in partnership with Simon Lewis, he has set up a specialist darkroom dealing with black & white specialist printing and color processes.

Tel/Fax: 0171 377 0773
Mobile: 0956 904759

Carles Mitjà left the chemical industry to become a photographer in 1980, specializing in editorial, industrial and advertising.

Currently works mainly with still life. Carles Mitjà also teaches photography at Escola de Fotografia de lan Fundacio Politecnica de Catalunya.

Tel/Fax: 72 59 4528

Rick Muller was born in upstate New York, 13 miles from Woodstock in the Catskill Mountain region. His interest in photography began in high school. While working at a photo studio he was accepted to the Rochester Institute of Technology where he earned an Associates degree in Professional Photography. After 1½ years of full-time assisting and two years of freelancing he landed the Mark Cross account that helped to put him into business. He has been in business for 12 years and is also interested in diving, skiing, cycling, martial arts – and is dabbling in product development.

Tel: 001 212 967 3177

Stig-Göran Nilsson studied photography at the Christer Stromholms School. He has also worked as a staff photographer for daily newspapers. He's had his own studio since 1982 and works for magazines, advertising agencies, industrial clients, and company annual reports.

Tel: 8 768 40 31 Fax: 8 768 16 02

Naoki Okamoto originally wanted to be a painter, and studied Fine Arts in Tokyo and Paris. On returning to Tokyo he took a photography course at a visual arts school and became a fashion photographer, working for many magazines and advertising agencies in Japan.

He currently lives and works in New York, producing art works (in photography and painting) some of which have been exhibited in several galleries in Soho, New York.

Tel: 212 864 2447

Australian-born **Kevin Orpin** has, for three decades, been one of Asia's most prominent commercial photographers. This award-winning photographer uses his creativity and experience in his work for local and multinational clients.

His clients include American Express, Cathay Pacific, Kodak and Cartier, among many others.

Tel: 852 2525 2008 Fax: 852 2521 8411

Greg Pease is a professional photographer who is based in Baltimore, Maryland. His assignments take him around the globe and his work has appeared in annual reports, capability brochures and advertising worldwide. His images have won awards from Communication Arts, Graphics and New York Art Director's Club.

Tel: 410 332 0583 Fax: 410 332 1797

Born in New York, working in London and Paris **Valerie Phillips** shoots fashion, music and portraiture for a variety of publications including the Independent on Sunday, British GQ and Spin magazine.

She is currently working on a portrait project involving Formula 1 racing drivers. She uses Hasselblad because of the way it sounds (!) and Polaroid for almost everything else.

Tel: 0181 883 0271 Fax: 0181 442 1193
Mobile: 0850 286520

Alan Powdrill is 29 years old and has a degree in photography from Edinburgh. He has assisted for three years and has been working as a professional photographer for a year. His areas of specialization are advertising, music publishing and design.

His list of clients includes Ogilvy & Mather Direct, Gold Greenlees Trott, Central Office of Information, Royal Exchange Theatre and Macmillan.

Tel: 0181 743 0588 Tel: 305 756 0136

Lanny Provo is a commercial photographer living in Miami. In the late 1980s he started to use the fisheye lens to do landscapes. The images have been used for book covers, magazine spreads, annual reports and for advertising. Photonica, a Japanese agency, handles a number of the images in the U.S. and in Europe.

Other work includes images of interiors and gardens, images for books and magazines, tropical food cookbooks, and various other assignments.

Tel: 305 756 0136

Graham Pym qualified as a graphic designer/illustrator but became more excited by the immediacy of photography. After a period of freelance work he set up the Flashlight group of studios which provide a broad spectrum of photographic expertise.

While he still enjoys people photography his area of specialization is still life as it offers much more potential to exploit color and texture.

Tel: 0171 722 1056 Fax: 0171 483 0721
Mobile: 0831 623417

Lindsay Robertson started his career working for advertising and industrial companies in the West of Scotland. He then moved to Edinburgh where he established a full service studio, working for major agencies and financial institutions.

His areas of speciality are food (especially curries!), landscape, and making the best out of difficult interiors. He enjoys the everyday challenges that a photographer is given, and the ability to solve them.

Tel: 0131 332 4167 Fax: 0131 539 7222

oan Roig was associated with Neus Portell n 1986, a stylist specializing in floral art. hey worked in partnership as Roig & ortell, specializing in food, audio-visual, nd still life. Their combined skills have led o them winning the Lux prizes in publicity nd food photography.

el: 3 427 9186 Fax: 3 427 62 48

Shahn Rowe is a South African photographer based in Johannesburg, Gauteng Province. After two years of military training, during which he acquired a lot of his photographic techniques by processing and printing while with the South African Airforce, he jumped into the deep end of professional photography.

His influences include work by photographers such as Albert Watson, Jean-Baptiste Mondino and Irving Penn.

He currently works in advertising photography, shooting a wide variety of subjects. He likes to work with great concepts which give him a lot of creative freedom.

Tel/Fax: 0027 11 884 3719

Spencer Rowell was born in 1958 and left school at 19. He worked on a local paper for six months before beginning work at an advertising studio in Nottingham for a total of 3 years.

While there he took a week's holiday and came to London looking for a job as an assistant. Although he didn't get the job he realized London was where he wanted to be. He was an assistant for 6 years in total after which he set up his own studio.

He works for most of the major advertising agencies and is now shooting film for commercials and TV.

Tel: 44 171 437 8755

Marshal Safron's father was a Press photographer in the early 40's and headed the Associated Press Office in Detroit.

Formally educated at the Brooks Institute, Marshal Safron ventured into illustrative photography and assisted an advertising photographer. He became a professional photographer in 1972, specializing in architectural photography on location and in the studio.

Tel: 213 461 5676

Pete Saloutos graduated with a History and Fine Art major from UCLA in 1969. A journey by VW camper from the Munich Olympic Games to Goa and a subsequent journey to Peru helped to produce material which was later used as the basis for multimedia shows. He taught commercial photography at Santa Monica College from 1977-90. In 1990 he re-located from Washington to Los Angeles.

His career in photography now spans 30 years. His list of clients includes: Bank of America, Pacific Bell, NIKE, Runner's World, Newsweek, U.S. Olympic Committee, Federal Express.

He says: 'My interests in photography are ever-changing. In addition to on-going assignment work, I am currently involved in computer imaging.'

Tel: 206 842 0832 Fax: 206 842 0927

Stefanos Samios studied photography at 'Paris-VIII St. Dennis' in Paris. He has worked as a fashion photographer since 1987 although he has been a keen and competitive photographer since the age of 15.

From 1988 he ran Phobia Image Studio in Athens. In 1992 he became vice-head of Akto, a private school where he teaches fashion photography to B.A. students.

Tel: 1 721 4410/1 725 0940

Charles Schiller is a New York City based still life photographer. He works on advertising, editorial and catalog assignments.

Charles uses both natural light and strobe to create his images.

Tel: 212 473 1440

Luciano Schimmenti had his first camera at the age of seven. On a visit to Germany in 1974 he acquired the equipment and experience to become a full-time photographer, and worked there for three years. He is now based in Sicily. He has had various exhibitions and has organized workshops with the contribution of Kodak.

He specializes in portraits, nature, architecture, landscape and furnishings.

Tel: 0921 88084/0330 66 4001
Fax: 0921 88084

Stuart Simons' extensive background in art and design is obvious in his painterly images combining traditional illustration techniques with photography. His pioneering style has graced many advertisements, books, brochures and CDs around the globe. Clients include publishers and corporations worldwide such as: Sony, RC Cola, Times Mirror Group, Simon & Schuster, and BMW North America for the Olympics.

He works with his illustrator wife Donna from a picturesque studio surrounded by beautiful woods and a pond in Westchester County, New York.

Tel: 914 764 9424 Fax: 914 764 9433

Raymond Tan has been a photographer for almost a decade. He regards photography as more than a career, bringing to every piece of work a degree of artistic meticulousness. He loves to experiment with props which he creates himself and with various lighting techniques. He regards himself as an artist by nature, being sensitive to his surroundings from which he derives much creative energy.

Tel: 479 4173 Fax: 479 4764

Mark Thayer is a 1980 graduate of The New England School of Photography. He currently works as a commercial photographer in Boston, Massachusetts. Working in all formats, both on location and in the studio, Mark can be considered a true generalist. During his 15-year career he has photographed everything from downhill mountain bike racing in the Sierra Nevada Mountains to revolutionary surgical procedures in the world's finest hospitals.

Tel: 617 542 9532

Robert Tran studied photography twenty years ago and ten years ago started commercial photography. He is based in the USA and Hong Kong. He specializes in people and still life photography.

U.S.A. Tel: 001 818 286 0907
Fax: 001 818 286 2762

Hong Kong Tel: 852 9093 6692
Fax:852 2896 2159

Frank P. Wartenberg began his career while he was doing his law degree. He was employed by a press agency on a freelance basis photographing concerts. He was one of the first to photograph The Police, The Cure and Pink Floyd in Hamburg.

After finishing the first exam for his law degree he moved into fashion photography, working for two years as an assistant. Since 1990 he has run his own studio and is active in the areas of advertising and fashion. He specializes in doing photography with light effects and also produces black and white portraits and erotic prints.

Tel: 40 850 8331 Fax: 40 850 3991

Gösta Wendelius is a professional photographer who lives in Umea and works all over Sweden. He is a specialist in advertising, industrial and annual reports as well as landscapes and adventure photography in the Scandinavian wilderness.

Tel: 90 11 6743 Mobile: 010 256 1050

Bill Westheimer is a self-taught photographer. His first experiences in photography were creating and performing a lightshow to accompany live rock music in the late 1960s, and assisting advertising photographer Dick Durrance II. In addition he has had extensive experience of black and white and Cibachrome printing.

His specialty is in the area of photo-illustration, using layering and manipulation techniques to create multiple images.

Tel: 212 431 6360

Milanese-born Stefano Zappalà worked as an assistant in his father's studio and others for about three years. At the age of 22 he decided to become a full-time professional photographer.

He specializes in advertising photography, mainly still life, working with some of Milan's leading agencies.

Tel: 581 06950 Fax: 581 14388

GLOSSARY

Aberration A lens fault. Some aberrations are actually used as part of a lens design, for example, the bowing of straight lines produced by a fisheye lens.

Airbrush An artist's coloring-in tool that can be used to create fine areas of tone. Can be used to color photographs although requires some skill for successful results.

Ambient lighting Another term for available lighting, which can be indoors or out of doors.

Apochromat An apochromat is a type of lens that uses a special kind of glass which transmits light in a more efficient way than normal lens glass. Apochromatic lenses give superior sharpness and control of distortion.

Artificial illumination Electric lighting. The variety of artificial illumination that is available indoors and out of doors, and the various color casts produced by them when used with daylight balanced film can be exploited for special effects. Tungsten lighting produces an orange result with daylight film, while most types of strip lighting gives a green cast.

B setting This is the basis of many a special effect shot that shows subject movement. It can also be used for exposures that last for hours, making it possible to make a night-time scene look like daytime.

Back projection This technique involves using an image (such as a landscape) projected onto a screen, with the aid of a slide projector, as a background for a still life or portrait subject.

Barn-doors These special flaps, fitted around the front of a studio light, are used for directing the illumination to a selected part of the subject.

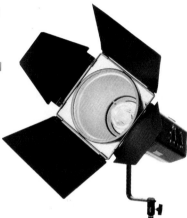

Bracketing This means taking a series of shots of the same subject at different exposure settings. It is a good way to assess the effects of over and under-exposure. It can be done manually but hi-tech SLRs have a more convenient Automatic Exposure Bracketing option.

Camera movements Certain medium and all large format cameras with bellows have camera movements ie the facility to alter the position of the lens plane to the film plane. This can be used to provide limitless depth of field as well as deliberate distortion of the subject's shape for specific purposes. (See also PC lens)

Center filter A center filter is required for use with certain panoramic camera types that have an ultra wide film format eg. 6x17cm, 6x19cm. This is to ensure that the light coming in through the lens is evenly distributed over the full area of the film frame, so reducing vignetting.

Chromogenic film This is a type of black and white film that has to be processed in color print film (C41) chemicals. It has a variable ISO speed range, from around 200 to 3200. Ilford XP2 is a chromogenic film.

Clip test The first three or four frames from a finished film can be processed to check exposure, lighting or whether a particular technique or ISO speed setting has been successful. This is called a clip test. Depending on results from a clip test, the rest of the film can then be processed accordingly.

Close-up attachments Various close-up attachments are available that fit onto a lens to provide closer focusing. Some fit onto the front of the lens while others fit between the lens and the camera body. The quality of results can vary.

Color temperature A light-source can either have a cool color temperature ie blue or a warm color temperature ie red, or different shades of these colors. Different strengths of filter are available to adjust the color temperature of a light-source to bring them close to neutral ie normal colors.
When using daylight film the cool (blue) color temperature of early morning light can be compensated for by using a pale pink or pale orange filter. And the warm (orange) color temperature produced by tungsten lighting on daylight film can be compensated for by using a blue filter.

Drop-bed A type of medium or large format camera which has a (mostly) fixed back which has a shallow box shape. The front part of the bellows and lens panel

rests on tracks on a platform that can be retracted into the box section when not in use. It is highly portable and has some of the bellows movements that are found on monorail cameras.

Often referred to as a field camera because of its popularity with those involved in outdoor location and landscape photography.

Duplicating film This transparency film can be found in 35mm, medium format and large formats. It has low contrast, good sharpness and good color reproduction which makes it useful for copies of original transparencies.

Dye transfer This is a special (and expensive) process for producing high quality prints that never fade.

Exposure value or EV An EV scale for a metering system shows the range of shutter speed and aperture combinations that it can handle that will produce a correct exposure. An EV range consists of two figures, a low number ie EV 1 to a high number ie EV 18. An EV 1 setting will give ½sec at f1.4 while an EV 18 setting will give ¹⁄₁₀₀₀sec at f16. The EV numbers are usually based on meter readings, based on a 50mm f1.4 lens and with ISO 100 film loaded.

Obviously, the lower the EV number at the low end of the scale, and the higher the EV number at the high end of the scale, the greater will be the range of exposures that the metering system can handle. Most mid-priced 35mm SLRs have an average range of around EV1 to EV 19 or 20, while some have more extensive ranges.

Extension tubes These fit between lens and camera body and give a range of different magnifications for close-up work. They usually come in sets of three, in manual or automatic versions, and give good results.

Filter factor All filters reduce the amount of light that reaches the film, some more than others. The filter factor is a figure that gives an idea of how much light is lost by using a particular filter, and therefore how much exposure adjustment will be needed to make up for this. Automatic exposure cameras will compensate for this automatically, though filter factors are useful to show how much the shutter speeds and/or apertures will need to be adjusted.

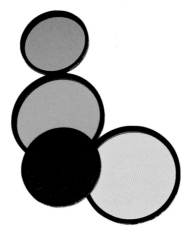

Filter holder An adaptor screwed onto the lens-front that takes slot-in filters.

Filter hood A type of filter holder which can be screwed onto the front of a lens and includes an adjustable bellows hood.

Flare This is an area of excessive brightness or a halo effect, noticeable when photographing towards or near a lightsource. Lens hoods can help to reduce flare, although in the right conditions flare can be used as an effect, such as in soft focus shots.

French flag An accessory that is used to obstruct or reflect light. An attachable clamp or arm attached to it makes it easy for positioning.

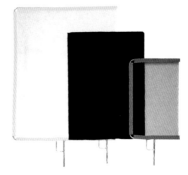

Gobo A device which has cut-out shapes within it to create shapes projected onto a subject or scene, when placed over a light-source such as a spotlight.

High key This technique is created by using a selective amount of overexposure so that colors become pale and detail is faint. It works well with subjects such as flowers and female portraits.

HMI lighting (HMI stands for Hydrargyrum Medium arc Iodine.) This type of lighting is more efficient than tungsten-halogen lighting and is daylight balanced. But it is more expensive than tungsten lighting.

Hot spot A bright, shiny area caused by uncontrolled illumination from a studio light or flash. It's especially noticeable if a shiny surface such as glass is included in the image.

Infrared index mark This is used as the suggested point of focus when using infrared film. Images shot on IR film loaded in a camera come to a focus slightly behind that of normal film. The procedure is to focus normally, note the focused distance on the lens barrel, then position this against the IR index so as to get correct focus.
Most lenses with a manual focus facility have an infrared index (IR) mark on the focusing section of the barrel.

Light Brush A torch-like device that is used for lighting specific parts of a scene or subject during a long exposure. Most provide color-corrected illumination and some have light-shaping attachments that fit onto the front.

Mirror lens A type of lens that uses a mirror which enables a long telephoto focal length to be compressed into a small space. These lenses are comparatively short but have wide barrels. Typical mirror lens types are 500mm and 1000mm.
They're ideal for photographing long-distance subjects. With a mirror lens out-of-focus highlights appear as ring-shapes.

Monorail cameras A type of large format camera that is attached to a rail or bar. It has lens panel and film back at either end, with a bellows in the middle. Focusing is achieved by adjusting the distance between the two panels.

Multiple exposure This technique enables one or more image to be included on a single frame of film. For a double exposure, for example, the exposure setting needs to be divided in half, one for each image.

Macro lens A special lens that can produce, on film, life-size images of small subjects (see also Reproduction ratio). Useful for ultra shallow depth of field.

ND filter An ND (neutral density) filter is used to reduce the amount of light entering the lens. Useful in very bright conditions or with very fast film, when the photographer requires a slower shutter speed or a wider aperture for a specific purpose.

Norman flashgun A special portable flashgun that has a higher power output than a conventional flashgun.

Off-camera flash A flashgun that is not used on-camera. Instead it can be connected to the camera by a flash cable or via a remote triggering device such as a slave cell.

Open flash A technique which uses one or more manually fired flashes to selectively light a scene during a long exposure. It is a popular method with architectural photographers, used for lighting interiors of buildings.

PC lens PC stands for Perspective Control. The positions of the glass elements inside a PC lens can be changed. The resulting image is similar to that produced by the camera movements of a large format camera, though with some limitations.
It's ideal for keeping vertical lines straight when photographing buildings, although the experimenting photographer may find other ways to use its properties for special effects.
Found in 35mm and some medium format camera lens ranges. All large format cameras have this facility.

Portable media Items such as Syquest and magneto-optical disks are examples of portable media, and are used in computer imaging. They are vital for transferring, distributing or storing large image files.

RAM This means Random Access Memory and is the most useful extra for those using computers for imaging and special effects. Plenty of RAM is required to produce and handle large color images at high resolutions.

Reciprocity law failure This occurs when the exposure time is longer, or shorter, than the range of shutter speeds for which a particular film was manufactured. So exposure times that are outside the margin of safety produce reciprocity law failure (sometimes called film failure). It generally occurs with exposures slower than a ½ second and faster than $\frac{1}{1000}$sec. The condition causes color shifts or casts which produce inaccurate colors. These can be corrected if required, but the unpredictability of the color shifts with various films can be used for special effects purposes.

Redeye An effect caused when flash illumination is reflected off a human subject's retina. The red coloring is caused by the blood vessels found in the retina. One way to avoid it: use bounce flash.

Reducer A special solution (eg. Farmer's Reducer) that reduces the density of a negative, transparency or print.

Replenishment The chemicals used in film and paper processing can be replenished, extending their useful life and saving on costs.

Reproduction ratio This is commonly used when referring to close-up photography. A lens or other accessory that offers a reproduction ratio of 1:1 means that it can produce, on a 35mm film frame, a very close, life-size image of the object being photographed. A reproduction ratio of 1:2 would be half life-size, while one of 2:1 would be twice life-size. So-called macro lenses are capable of reproduction ratios of 1:1. Some close-focusing zoom lenses are capable of reproduction ratios of 1:2.

Reversing ring A threaded ring which enables a lens, usually a 50mm standard, to be fitted onto the camera body back-to-front. The benefit is that the lens is then capable of focusing much closer than it normally would.

Scrim A device, made of a thin translucent material, that acts as a diffuser.

Second-curtain flash sync A flash feature that is available with high-level SLRs and can be useful when photographing moving subjects. It works like this: because of the design of conventional shutters in 35mm SLRs a panned shot with flash plus slow shutter speed causes a streak effect in front of a subject that is moving. With second-curtain flash sync the streak effect will be in a more natural position, that is, following or behind the subject.

Slave cell An independent light sensor that can be used to trigger one or more flash units. Useful for photographing building interiors as well as for creating dramatic lighting effects.

Strobe lighting A strobe lighting unit gives out regular and rapid bursts of bright illumination. It can be used to take several images on one frame and to produce photographic sequences of fast-moving action.

T setting This is similar to the B setting. The main difference is that the shutter stays open on first press of the shutter button after the finger is lifted off. A second press, after the required exposure time has ended, will then close the shutter. The T setting is a feature that is found on some large format cameras.

Vignetting Darkening at the edges of the frame, usually the corners. This often occurs when a very small aperture is used. It can therefore be avoided or minimized by using a wider aperture. It is also a characteristic of some early cameras. Vignetting can therefore be used to create an old-fashioned look, especially if the image is sepia-toned. It's an effect that is popular with some portrait and wedding photographers.

ACKNOWLEDGMENTS

Thanks to the photographers who so generously gave their images, their time, and an insight into some of the creative secrets that they use for their special effects photography.

From the start our intention was to obtain the best images we could in this particular field. We were overwhelmed by the response and we are delighted with the results. We trust that the book has done justice to the photographers' images, their creativity, and their photographic skills.

Phil Kay, the book's designer, who with a clear, simple and effective page design has produced a fitting environment in which to display the special effects images and information.

To Kate Simunek, the artist who has skilfully transformed rough reference diagrams into real-life illustrations of the photographic set-ups that went into creating these special effects.

As well as the right ideas, photographic special effects need the right equipment. Companies and individuals we would like to thank for the use of their product shots are: Keith Ruffell of Introphoto Ltd. and Tim Haskell of KJP.

Finally, thanks to Simon Lewis for the use of his gum bichromate image (above).